DI020231

MEMOIR & LETTERS

OF THE LATE

THOMAS SEDDON,

ARTIST.

AMS PRESS
NEW YORK

MEMOIR AND LETTERS

OF THE LATE

THOMAS SEDDON,

ARTIST.

BY HIS BROTHER.

JOHN P. SEDDON

LONDON:

JAMES NISBET AND CO., 21 BERNERS STREET.

M.DCCC.LVIII.

Library of Congress Cataloging in Publication Data

Seddon, Thomas, 1821-1856.
 Memoir and letters of the late Thomas Seddon, artist.

 1. Levant--Description and travel. 2. Printers,
British--Correspondence, reminiscences, etc.
I. Seddon, John Pollard, 1827-1906, ed.
ND497.S42S4 1972 759.2 [B] 72-148300
ISBN 0-404-05668-7

From the edition of 1858, London
First AMS edition published in 1972
Manufactured in the United States of America

AMS PRESS INC.
NEW YORK, N. Y. 10003

TO

THE COMMITTEE AND SUBSCRIBERS

OF

"THE SEDDON SUBSCRIPTION FUND,"

FOR THE PURCHASE OF THOMAS SEDDON'S PICTURE OF JERUSALEM,

SINCE PRESENTED TO THE NATIONAL GALLERY,

This Memoir of the Artist

IS DEDICATED BY THE EDITOR,

IN SINCERE GRATITUDE FOR THEIR KIND AND SUCCESSFUL

EXERTIONS.

PREFACE.

THE following is the brief sketch of a life that has been
judged by many, who watched its course, to have left
fruits worthy of some permanent memorial. The
Letters, which record its most eventful passages, will
best tell its tale. The Editor, fearful lest he should
mar by comments of his own the impression made by
the character of one whom he loved and revered so
greatly, has done little more than add what is necessary
to make connected and intelligible the autobiographical
materials at his command.

To have withheld these, from deference to any per-
sonal feelings, when strangers as well as friends have
alike come forward to honour the memory of one whose
name had else "been writ in water," would hardly have
been right. For it is the belief and hope of the Editor,
that the following pages will shew to those who are now
struggling in the arduous path of art, how with a noble

and unselfish aim one has toiled and trod in the same
before them; that, seeing sometimes his "footprints"
in the way, they may "take heart again" in their dis-
couragements; and, above all, that they may learn,
with him, to hold art, and success, and all things, but
secondary to the one thing needful, and seek, as he did,
to forward humbly by their work, as best they may, the
cause of their Saviour.

The Editor desires to acknowledge with gratitude the
assistance he has received from the Rev. T. F. Stooks
and other friends in the preparation of this volume;
nor can he omit to mention particularly among these,
his Publisher, from whom the subject of this Memoir
received kindness also.

6 WHITEHALL, 21st *May* 1858.

CONTENTS.

CHAPTER I.

EARLY LIFE AND BUSINESS CAREER.

AFTER the spirit-stirring narratives of Christian heroism and successful enterprise which have lately roused and rewarded public attention, it is only a limited audience which can be expected for the " still small voice" of the following pages. They recount the career, abruptly concluded, of an earnest and highly gifted artist ; and although there was abundant promise of his attaining the highest place in a special department, to the general reader his name will even now be unknown : for just as he was beginning to be famous, the pencil dropped from his hand, and on his grave was planted the laurel which came too late for his living brow.

In telling the story, we have adopted his own principles as an artist. There is no attempt to idealise, since in his character we believe that there was enough of genuine goodness and professional enthusiasm to secure the sympathy of kindred spirits. Those who may be seeking a hero for a biographical epic, we must refer to subjects more separate from the homely ways and everyday experiences of common life. Such persons will find here but few startling incidents, and will, perhaps, regret the absence of more dazzling traits

A

of genius. They would doubtless have wished introduced as accessories some of those great names which give a facti tious interest to the lives of some very ordinary people. But the biographer of THOMAS SEDDON must try to do on paper what he himself in his lifetime tried to do on canvas. He must endeavour to be true. Form, colour, atmosphere— he must take them as they come ; and, without any consideration as to what might have been, he must exhibit the young artist as he was.

About the year 1750, George Seddon, of a Lancashire family of that name, came up to London, and established there a very extensive cabinet manufactory. It was continued by his sons and grandsons successively, first within the city of London, and afterwards in Gray's Inn Road. His great-grandson, Thomas Seddon, the son of Thomas and Frances Nelson Seddon, was born in Aldersgate Street, on the 28th day of August 1821.

Of his childhood there is nothing remarkable to relate; though many little incidents shewed even then that he was ardent, affectionate, and unselfish to no ordinary degree. At the age of six years and a half he was sent to the school of the Rev. Joseph Barron, at Epsom, which was afterwards removed to Stanmore in Middlesex, and there he remained till about sixteen years of age. The school was conducted on the Pestalozzian system. As the studies of the boys were considerably varied, and their attention was directed to the natural sciences as well as to the classics and mathematics, his mind was allowed to find and follow to a great extent its natural bias. During the holidays it was his chief delight to collect shells, minerals, birds' eggs, and in-

sects, and in search of such curiosities he would range over wide tracts of country. A taste for drawing was early indicated. He was seldom without a pencil in his hand, and the blank leaves of lesson-books, as well as every available scrap of paper, were covered with sketches of animals and caricatures of his schoolfellows. He was fond of books, and often gained places in his class by the opportune remembrance of facts which he had read in Plutarch's Lives, and other favourite authors. When any scene or incident had fired his imagination, he strove to embody it in a picture; and there still exist some few drawings illustrative of " Marmion," full of spirit, and shewing considerable knowledge of the dress and armour of the period.

After leaving school he entered his father's business. The occupation, however, was uncongenial. From a sense of duty, and from an affectionate desire to assist his father, he did his utmost to master its details ; but he could never conquer a deep-seated disinclination. His leisure was devoted to drawing, and in the hope of at once gratifying this taste and rendering it subservient to professional purposes, his father sent him in 1841 to Paris, to study ornamental art. Here he made great proficiency as a draughtsman and designer, and, after a year's sojourn, returned, speaking the French language as fluently as his own. But from his residence in that gay and seductive capital he derived no other benefit. Amongst idle acquaintances he contracted a taste for pleasure and dissipation, which unnerved his mind, and made it doubly difficult to concentrate his energies on any irksome calling. Happily, however, he brought back a large measure of his habitual conscientiousness, and was

kept from entirely deserting his post by his anxiety to serve his father. Thus, in the year 1842, we find the following memorandum :—

"My present great duty is to assist my father in every possible way, for the wants of my family require it; but if by any arrangement they should be secured, I shall then feel at liberty to choose a line of life more congenial to my tastes. I must, however, watch carefully not to be influenced by self-will, or carelessness to my father's wishes. If I should feel it right to devote myself to the business, I will devote the time that I shall have disengaged to drawing in its various branches."

Again, speaking of his wish to become a painter:—

"My father objects that I could never live on fifty pounds a-year, and that I have not the energy or habits of work. As to the former point, I will not say that I can; but having many things by me, I should not require more for one or two years, and afterwards I should be able to earn enough to supply myself amply. As to the latter, I am convinced that a man can do what he will, if only he have sufficient inducement to make the effort. I have not yet had that inducement. 'Better is an handful with quietness, than both the hands full with travail and vexation of spirit' (Eccl. iv. 6). 'For God giveth to a man that is good in his sight, wisdom, and knowledge, and joy : but to the sinner he giveth travail, to gather and to heap up. This also is vanity and vexation of spirit' (chap. ii. 26). A man should labour, and may enjoy the fruit of his labour, and lay by for the evil day; but it is the sinner who travails, in order to gather and to heap up riches—who gives his whole time to heap up store upon store, unsatisfied with

the gradual and certain provision that a diligent application to the duties of his station will procure him. The word *travail* well expresses the painfully anxious, all-absorbing struggle of a man intent merely upon getting this world's goods. I have always wished to make a fortune as quickly as possible, which, I fear, is not being contented with the lot in which it has pleased God to place me. Am I not in danger of travailing for that which perisheth ?"

Thus resolved to make the best of circumstances, he applied to the work before him. For the present, he must deny himself, and leave "high art" to happier aspirants. At least for a season, it was to be his vocation to make designs for furniture, and superintend their execution. He therefore wisely acquiesced in what appeared to be his providential destiny; and instead of calling it a bondage, and fretting at his chains, he at once bravely threw into it all his heart and soul, and determined to excel. He applied himself to master the various styles of ornament and art ; he attended the architectural course of Professor Donaldson; he frequented the library of the British Museum, examining with care all the numerous works likely to be useful in his studies; he joined the Decorative Art and the Archæological Societies, and became a zealous attendant on their meetings. And his proficiency was conspicuous. In 1848, his design for an ornamental sideboard obtained the prize—a silver medal and twenty pounds— offered by the Society of Arts; whilst, in his own department, the grace and originality of his creations rendered his services increasingly essential. Nor was he content to provide the designs and working drawings. If ornament peculiarly rich or elaborate was required, to assist the

carvers he prepared models for their guidance, and was constantly urging them to imitate those which Nature herself supplied. This, however, with the greater number of English artisans, was up-hill work. When they were apprentices, they had learned to carve oak and ivy leaves, and they saw no use in continually reverting to the fields and the garden. Indeed, the more wooden that flowers and foliage were, the more thoroughly did they adhere to the traditional type of the English carver. It was in vain to tell them how much taste and intelligence their brother-craftsmen in France carried into the same employment, and how Parisian workmen often spent their leisure hours in searching for natural examples of the subjects which they were required to execute. The French carver was an artist, the English carver was content to be a mechanic; and it was only by degrees, and after great exertions, that he was able to inspire a few with something of his own enthusiasm.

The daytime was passed in business; but the evenings he devoted to that fondly-cherished pursuit which he could never finally forsake. First as a student at Mr Lucy's school in Camden Town, and afterwards at Clipstone Street, where he drew carefully from the life, he made signal proficiency, which was afterwards increased by practice in the society of a few personal friends. And it ought to be mentioned, as a proof of his mental vivacity and vigour, that, simultaneously with the duties of his calling, and his more agreeable artistic recreations, he was fast extending his acquaintance with the best literature of his own country and of Europe. French he had already mastered during his residence in Paris; and it is worth recording, to shew

his care for even the odds and ends of time, that he acquired Italian and German chiefly by writing out extracts on slips of paper, which he carried in his hand and committed to memory in his daily walks from Kentish Town to Gray's Inn Road.

He visited North Wales in the course of the summer of 1849, in the company of his brother, and spent some weeks at Bettws y Coed. Situated at the confluence of the Conway and several smaller streams, this village is surrounded with varied and beautiful scenery, and is a favourite resort of artists. During that summer many well-known members of the Water-Colour Societies were staying there, and in their company Thomas Seddon commenced his first real studies of landscape. Parties of four or five together would start every morning, attended by a boy to carry their materials, and having selected neighbouring positions, would sketch all day, and returning in the evening, they would all meet to compare their works and discuss questions of art. Even at that period he was distinguished by painstaking and care. He would stoutly maintain that it was far better to secure but two or three good studies during the usual stay which each artist was able to make, than to confine their practice, as was usual, to mere sketching. Instead of the single day which they usually devoted to an important scene and a large canvas, in his opinion weeks would hardly suffice; and he would applaud, in spite of the decision of the majority, the heroic resolution of an amateur who declared that he would give himself three weeks' hard work to endeavour to draw one single branch of a tree properly, and that if he succeeded he would continue his studies, but that if he failed he would abandon the brush for the fishing-rod, and

decamp. A sketch made by him in the visitors' book at "the Royal Oak," to which every artist is expected to contribute, is characteristic and amusing. It represents, what he himself had once witnessed, a carriage and four dashing through the village—unquestionably one of the most beautiful in Wales—and startling the repose of geese, pigs, and other roadside loungers, whilst the enlightened occupant of the vehicle, an old gentleman in search of the picturesque, is comfortably asleep within, as also the portly footman, and the lady's-maid in the dicky behind.

On his route from Wales he stayed for a day at Holywell, where there is a beautiful Gothic structure over a fountain, which flows thence into a pool in a courtyard in front. Here he began sketching the bathers with their wet dresses clinging around them, and was soon surrounded by troops of the inhabitants, to many of whom he gave a few pence to induce them to enter the water, so as to furnish him with subjects to sketch from. The amusement that this created was excessive, and he was besieged with entreaties for portraits. Indeed, they begged him to remain till the Saturday, when they would receive their week's wages, and would give him commissions enough to make a small fortune, which, however, to their regret, he was forced to decline.

In the following summer, 1850, he made an excursion to Paris, and thence to a spot called Barbisson, in the forest of Fontainebleau, which is frequented by the French landscape artists in much the same manner as Bettws is by the English. There he made three studies in oil, which shewed very great advance over his sketches of the former year. One view of an intricate piece of copse mingled with fern, and limestone boulders in the foreground, was bought after

the exhibition of his works at the Society of Arts in 1857. The following is an extract from a letter written from Barbisson, and gives an insight into the manner of life of the artists who frequent it :—

"BARBISSON, *Wednesday.*

" MY DEAR J——,—. . . The forest is now becoming most beautiful with the autumn tints, which are coming very rapidly from the hot sun. I have not had a single wet day since my arrival. We now, as it is full moon, take a walk every evening either in the forest or among the rocks. I wish you were with us. The effects are much more beautiful than during the day; among the rocks and sand especially it is most mysterious. Last night we went to a cavern about a mile and a half off. We thought we would illuminate it; so we cut branches of pine, stuck them all round, and lighted them, and began to brew a bowl of punch by torchlight; but unfortunately we forgot the smoke, and were obliged to retreat to the rocks outside. What with the torches and our outlandish costumes, we looked a most awful set of banditti; and being all armed with pikes to climb over the rocks, we were passably picturesque as we sate in a circle round the flaming bowl. I must tell you the cause of our jollification. The Government intended to cut down the greater part of the Bas Breau, the oldest part of the forest, and close to the village, and to replant it with young trees. All the trees were marked, and the destruction was to have begun soon; however, the artists represented that it was invaluable for the landscape painters of France, and authentic news arrived last night that it was to be spared. I have been painting in oil every

day, and I hope making a little progress, but it is slow work.—Your affectionate brother,

"THOMAS SEDDON."

Soon after his return from this excursion, he reverted to a plan which he had for some time entertained—namely, the establishment of a school for the instruction of workmen in drawing. Having consulted some of his artist friends, who willingly entered into the scheme, and offered their gratuitous services as teachers, it was agreed to make the attempt. They called on many influential persons in the neighbourhood, and on several leading artists and architects, but enlisted the sympathy of few, as it was asserted that the Government Schools of Design supplied the supposed desideratum, and that even if a class were opened, workmen would never appreciate or attend it. To this they answered that the Schools of Design were not intended for the working people, and that their stringent rules and system, though suitable, perhaps, for their own students, effectually debarred the attendance of artisans, whom it was now intended to invite to come, after their day's work was done, in their ordinary dress, and without formality; while the latter objection was triumphantly confuted by an attendance which shewed how remarkably the apathy of former years was replaced by the desire of improvement.

Some gentlemen, however, including among others Professor Donaldson, Mr George Godwin, and Mr S. C. Hall, warmly supported the scheme, and it was agreed to hold a public meeting at the St Pancras Vestry Rooms, to which workmen should be invited, and that the proposal should be laid before them, in order that it might be seen whether they would be willing to adopt it or not.

Previously to the meeting, he exerted himself in going through the various streets of the parish, calling at every shop where it appeared likely that there might be workmen to whom drawing would be useful ; and personally explaining the intentions of the committee, he urged them to come to the meeting and judge for themselves.

The result was, that on the appointed evening not less than eight hundred workmen made their appearance, of whom two hundred at once enrolled their names as students. Large rooms were taken in Camden Town. Mr W. Cave Thomas, who had kindly volunteered his services, was appointed master, and Mr J. Neville Warren, as secretary, gave up a large portion of his valuable time to its management ; and although, as might be supposed, the numbers fell off after the first enthusiasm had abated, about a hundred continued in steadfast attendance, and the proficiency of most was really astonishing. This was, no doubt, principally due to the system which had been adopted from the first, and which taught the pupils to copy from objects, instead of from drawings, as practised then in the Government schools. In the course of a very few months many of the men and boys, who had received no previous training, were able to copy elaborate casts with such fidelity that it was difficult to discover errors in their work.

Satisfactory as were the practical results, the payments of the students were insufficient to meet the expenses, and the number of subscribers was very limited, so that it became necessary to take some steps to bring the establishment into notice, and to obtain an increase of funds. For these purposes the committee resolved to get up an exhibition of works of art, during the Christmas holidays at the close of

the year 1850. Into this scheme he entered with his usual energy, and in order to complete the hanging of the pictures and other arrangements within the specified time, he exerted himself beyond his strength, and remained the whole of one night at the rooms, sleeping upon the floor. This imprudence brought on a serious illness, the results of which had the most important bearing on his future life, as will be seen in the following chapter.

CHAPTER II.

COMMENCES HIS COURSE AS AN ARTIST.

THE rheumatic fever, contracted by sleeping on the floor of the Exhibition-room, brought Thomas Seddon to the brink of the grave. For a long time his life was despaired of; and even when his unlooked-for recovery took place, it was found that his originally vigorous constitution had sustained a shock from which it never entirely recovered.

From his youth he had known and confessed the value of religion, and had made frequent efforts to live according to its rules; but never having given himself wholly to God, his better resolutions were again and again overborne by besetting sins. Passages like the following shew how serious his occasional feelings were. They were written in his journal in 1844, and after a severe affliction:—

"I thank my God for His merciful goodness to me in His fatherly chastisement. Lord, pardon me, and for Christ's sake keep me from presumptuous confidence. Thou hast said, 'Whom the Lord loveth, He chasteneth.' O my Father, forsake me not, for Jesus' merits. Pardon me, and lead me to Thee; and should adversity be better for me, let me truly say and feel, 'Thy will be done,' and let me kiss the rod."

Again :—

" I thank God that He has allowed me in some measure
to see how gracious has been His fatherly hand, and how
truly necessary it was that I should be cast down. If,
Lord, it should please Thee that this cloud be only for a
season, O change my heart and renew a right spirit within
me. But my heart is desperately wicked ; and if Thou
seest that I cannot be drawn to Thee without further trial,
help me to bow in resignation to Thy will. I will endea-
vour, with Thy help, to leave the morrow in Thy hands,
and to serve Thee day by day."

And, once more :—

" O Lord God, humble me. Help me to be not slothful
in business, but fervent in spirit, serving Thee. Help me
by Thy grace, through Christ, to be a faithful *servant*, em-
ploying both my time and money in Thy service and to
Thy glory. Help me to employ the talents Thou hast
given me diligently, and never to speculate on the morrow.
May I cast all my care on Thee, who *carest* for me !"

Such reflections, written for his own guidance, shew that
he then ardently desired to live in the service of God ; but,
though knowing so well what was right, he too often gave
way to the impulses of his natural love of excitement and
pleasure, and did what his conscience afterwards reproved.
Finding himself thus unable to reconcile his practice with
the standard of religion, and feeling that so long as he con-
tinued to offend in one point he was breaking the whole
law, he ceased to make any religious profession at all, and,
from the horror of cant and hypocrisy which he always ex-
pressed, he even discontinued his attendance on public wor-
ship. In this state of mind he was far from comfortable ;

his buoyant natural spirits, indeed, were such as to deceive often himself as well as his friends, but conscience would at times make itself heard, and he would then suffer great depression.

In this condition he remained until the illness of which we have spoken, and which doubtless had been sent to afford him a period for reflection. Of his danger he was well aware, and had but little expectation of recovery; in his trouble he sought the Lord, and through his kind friend and minister, the Rev. T. F. Stooks, he was enabled to apprehend and accept God's pardoning mercy in the Saviour. Having been accustomed to view with the greatest distrust what are called deathbed repentances, though he prepared for death in submission to the Divine will, he prayed earnestly for recovery, in order that his sincerity might be tested. His prayer was graciously answered. After weeks of pain, he arose from his bed a wiser and a happier man; and although the many natural excellences of his character rendered the change less conspicuous than it might otherwise have been, those who knew him best regard that sickness as the turning-point in his spiritual history, and the commencement of his practical Christianity.

Almost coincident with it was the commencement of his professional career. We have seen how his entire soul was absorbed in Art; but hitherto he had dutifully repressed his aspirations, and had indulged the luxury of painting only at spare hours, and during his yearly holiday. The time had, however, at last arrived, when he felt that he could follow the bent of his own mind without any sacrifice of the interests of his family. His father's business was about to be removed from Gray's Inn Road to New Bond

Street, and it appeared that arrangements might be made to dispense with his services, and to enable him to carry out the views he had so long and ardently desired; at the same time he would be able occasionally to assist with his advice and designs in matters of taste, and this he continued to do for a considerable time. The opportunity thus offered he gladly seized, and took steps to enable him to follow Art as his profession.

Many would have thought it too late in life, for he had now reached his thirtieth year. But he was young in heart as ever; and if sickness had somewhat impaired his strength, from that quiet chamber he brought back with him elements which go far to secure success—deliverance from bad habits, sobriety of spirit, and hope in God. He at once took chambers in Percy Street, together with his younger brother, and set to work in earnest.

The first thing he undertook was the completion of a picture commenced some time before. The subject is " Penelope." In it she is represented sitting by the side of her web, at early sunrise, near an open window, and resting after her night's work of unravelling what she had done on the day preceding. She is dressed in a loose purple robe, with her feet resting on a leopard's skin. Suspended from a loom is the web, shewing the heads of Ulysses and his companions. Her damsels are asleep in an adjoining apartment, separated partly by a curtain, and lighted by a lamp, the rays of which are paling before the beams of the morning. The pains he took to secure truthfulness in a subject which, by its very nature, seemed to preclude it, were extraordinary. He constructed a model of the apartment in which the heroine is represented, with an opening for the

window, with the curtain partition, and with the loom itself ;
and he hung up a taper in order to study the effect of the
double light ; and at the British Museum and elsewhere
he studied most carefully the costumes and manners of the
Greeks. There is considerable simplicity in the composi-
tion, but it has a fine breadth and harmony of rich colour-
ing ; and many of the accessories, such as the leopard's
skin, are painted elaborately and powerfully. He sent it
to the Exhibition of the Royal Academy in the following
year, but it was hung in the very top row, where it could
only be seen through an opera-glass, and, of course, attracted
no attention. However, it was some comfort to his friends
to hear the strong terms of commendation in which it was
noticed by connoisseurs sufficiently enterprising to search for
it in its exalted position. In an address delivered at the
Society of Arts after his death, Mr Ruskin praised it in
energetic language, and spoke of it as a picture which had
given him a high opinion of Mr Seddon's genius. It is
now in the possession of George Wilson, Esq. of Redgrave
Hall, Suffolk.

In the month of August in this year (1851), he visited
Wales, for the purpose of recruiting his health, and in order
to take some sketches from nature. The following letter
was written from the house of his friend, Edward Hawkins,
Esq., at St Briavels, upon the banks of the Wye :—

" St Briavels, Gloucestershire,
" *September* 14, 1851.

" Dear John,—I am delighted to hear you have re-
turned safely from Venice, though I wish you could have
stopped longer. I leave this to-morrow, and shall finish a

study I have been making at Tintern. This is a very lonely spot. We possess a castle which is rather complete, and are on the top of a high hill about a mile from the Wye. When the weather is clear enough we can see the Welsh hills near Pllhwhlhwermlly, which, again, is near the celebrated Brlhwrmllhlwelhmwr, or Devil's Punch-Bowl. It is a fine country for roaming over—very broken and well wooded. We went to Tintern last week, and thence to Chepstow, and saw the castle by moonlight. I hope to get a sketch of it on Tuesday, and I shall get to Trallwm in the evening. I caught a sight of lovely Redcliffe coming, and shall examine it on my return. I am certainly stronger, and I have made two useful studies ; *non è tutto perduto.*

"I send a few ferns, which I will trouble you to plant on the further promontory of the Fernery in the garden, as they do not want much wet—and do not let their necks be buried.

"I hope you have a goodly portfolio with you. Kind love to all.—Your affectionate brother,

"THOMAS SEDDON."

From St Briavels he proceeded to visit his uncle, Charles Thomas, Esq., at Trallwm, in the county of Glamorgan. There he was not able to work much out of doors, as the winter was approaching, but he painted a careful portrait in oils. He gained, however, greatly in health, having come down quite an invalid, and under strict orders to avoid any violent exertion, on account of an affection of the heart, which had remained since his illness. Being, however, passionately fond of riding, he hunted regularly with the hounds kept by the Squire of Llanharran, and, disregarding

the caution he had received, joined the sport with his usual impetuosity. But, as it happened, the rough exercise did him no harm. He rapidly gained in health and spirits, and returned to London in the beginning of 1852, free from all bad symptoms, and rich in picturesque materials, many of which he had gleaned in his various rides over the Cambrian hills.

On his return to town, he resumed his life-studies at Clipstone Street. His future plans were also the subject of thought. A proposal had been made to him to accompany to the East his friend W. Holman Hunt; but the project was not yet mature, and as some of his sisters were at Dinan, in Brittany, he at last determined to spend the ensuing summer there.

CHAPTER III.

RESIDENCE AT DINAN, AND DEPARTURE FOR THE EAST.

TOWARDS the end of the summer of 1852, he went to Dinan; and the following letters will sufficiently describe his occupations there:—

> "HAUT BOURG NEUF, DINAN,
> "*August* 1852.

"MY DEAR BROWN,—You will be horrified to hear that I have not begun anything yet; but since my arrival it has rained every day. I began a sketch yesterday; but at one o'clock I was obliged to pack up in hot haste, and just got in before a tremendous thunderstorm: and it rained all the afternoon. . . . I was too late for the Exhibition at Paris; but I saw the 'Œuvres récompensés,' which I think would have made you groan. A very, very few of the best looked like clever half-finished works: not a single good landscape. At the Luxembourg, Rosa Bonheur's 'Oxen' looks like a charming poem by the side of the Académie treacle: the landscape and all is *une nature vaporeuse et fraîche;* and there is a peasant in a blue blouse against the blue sky, which would ravish your soul. The re-arrangement at the Louvre is a great improvement; and the great

Paul Veronese and the Titians look beautiful after the cleaning. I confess with shame that the Raphaels looked uninteresting, excepting the portraits, and that lovely head, of which I have a lithograph. ' Vive l'Angleterre !' I believe we shall beat them all in time; I only despair of the grand Titian. I hope to become a *passe-maître en chevalerie.* I have got the Roi Réné's book on 'Tournois' to read. He is such a courteous old gentleman, a perfect connoisseur of the olden time, who, if he lived now, would buy Hunt's pictures, and write the handbook of ball-room etiquette."

" DINAN, *Sept.* 1, 1852.

" DEAR BROWN,—I have now got to work; but I bitterly regret the three weeks lost in Paris. I did not stay for my own pleasure, I assure you. The first fortnight after I came here was perseveringly and drenchingly wet; since then, tolerably fair ; but I am terribly teased with dull fine days. However, I have begun what was to have been a sketch; but, with my usual luck, have chosen almost the most complicated thing I could find. It is a quiet, sunny valley, with, I think, specimens of every tree in the universe, seen between the dark trunks of beeches and chestnuts, which arch over above, and a regular open-work screen of young poplars on the left. I began it about 16 by 12; and have already been eight working days, and shall probably be five or six more.* I did not feel strong enough three weeks ago to work hard, but now I think I am up to anything reasonable in the working line. My brain was quite dry in London, and I could not screw out an idea; but here, from being quiet all day, I suppose,

* This picture was bought by a lady in Yorkshire.

I have an *embarras de richesses*, the difficulty being to keep thinking of the same subject two days running; so I religiously dot down everything that strikes me; and I have a perfect *mêlée* of Bible themes and chivalry. First, Keats's ' Ode to the Nightingale' set me off on

' The selfsame song cheer'd the sad heart of Ruth,
 When, sick for home, she stood in tears amid the alien corn;'

and I made a design and drew it out on canvas, when the impossibility of finding a Christianlike corn-field brought me up short. Here they tie their corn in little wisps, like plantain-seed for canaries; and as they only cut off about eight inches of straw with it, the field is left so unlike English corn-fields that H—— judiciously observed, ' No one would recognise it,' and Ruth's legs would have been hidden as high as the knee. Then the good King Réné's *chansons* give me divers chivalric impulsions. But my greatest thirst is to paint Elijah, and the old prophets of Baal as they leaped on their altar and cut themselves with knives, crying, ' O Baal, hear us !' And, again, when Jehoshaphat and Ahab, seated on their throne by the gate, hear the false prophets (1 Kings xxii. 10, &c.); and Zedekiah made him horns of iron, and said, ' Thus saith the Lord, With these shalt thou push the Syrians, until thou have consumed them.' But these must wait for Syria. I should make regular wild-looking Arab conjurors, with long tangled hair. I think that either would be a glorious subject, and quite unlike the classic mode of representing Scripture subjects.* And I think of painting Shakspeare playing Hamlet as it was really played at the Old Globe, with the stage all hung round with black, and the young

* His sketches for the above subjects have been preserved.

gallants seated on the side of the stage on the ground, eating nuts and oranges, and flipping the shells at the pit.

" I paint till five or six every day. This is not at all a country I should remain in if I had my choice. You cannot get any simple thing. All their trees are small, and their number legion. There are lovely valleys, but they are full of small poplars, an inch thick; and every field is filled with small apple-trees, not ten feet apart; and the people are civilised—not Bas Breton at all."

The little landscape above mentioned he sent to the Exhibition of the Royal Academy in the following spring; and it found a place, as will be seen from the following letter to his brother :—

" *July* 3, 1853.

" They have hung my small picture very fairly, on the ground in the middle room ; but it is seen. Landseer's pictures are very fine ; Danby has a beautiful coast scene— a rock-bound shore, with the gaunt ribs of an ancient wreck lying before the setting sun, skeleton-fashion, among the breakers, and little gulls deliciously tripping on the wet sands in the sun's gleam. In the sculpture-room there is a recumbent statue of some peer or lord mayor, in full coronation costume—ruffles, frilled shirt, trunk hose, silk tights, a profusion of small daggers and large tassels, with his hands in the regulation devotional attitude, and a most intensely delighted smirk on his face, at the idea of going up to heaven in all this toggery."

The plan for visiting the East having been definitely

arranged between Mr Holman Hunt and himself, he was much occupied during the spring of 1853 in making the necessary preparations, and in completing the works which he had in hand. He also executed a series of designs for furniture, and wrote the accompanying letterpress for a work which Messrs Blackie were then engaged in publishing.

In the beginning of June he returned from London to Dinan, and commenced a large and elaborate landscape of the ruined monastery of Léhon, taken from Mont Parnasse, with the Bécherelle hills in the distance. It was purchased by William Leaf, Esq., and was exhibited in the Royal Academy in the following year.

It was not till the beginning of winter that he actually started. The following letter recounts his journey from Dinan to Paris :—

" PARIS, *Tuesday, Nov.* 15, 1853.

" DEAR E——,—I can now tell you positively what my movements will be, for I found two letters at the *poste restante* from Hunt, giving full consent to Cairo ; the second saying that the idea of crippling my movements made him nervous, and begging me not to wait for him, but if he could not get to Marseilles in time, to proceed to Egypt, where he would join me ; so I have told him that I will do so. I find so much to do to my picture that I shall devote all the daylight to it to-morrow, and see then if another day is absolutely necessary ; if so, I shall leave on Saturday. I have determined that no days are to be idle, so I made a sketch of the old hospital of St Ives, to make a beginning. We had beautiful weather, and the night was not nearly so

cold as the morning on which I left Dinan. I had the
pleasure of Mons. Jeune's company in the banquette of the
diligence, and found him on extremely intimate terms with
Mastodons, Megatheriums, and other old gentlemen who
were somebodies in their day. . . . I have now one
thing to do in the next six months, and with God's help I
will do it, and come back with something gained in my
profession. I think the only place I shall stay at on my
way will be Avignon, which, I am told, is very picturesque.
I was much pleased with my journey up, and with the
country about Nogent, which is rather like Hampshire—
fine hills, heaths, and scattered forests. I called this morn-
ing on a very clever landscape painter, who shewed me a
portfolio of sketches taken on the Danube and in Hungary,
and who strongly advised me to make slight sketches, and,
like himself, give up working from nature; at which I
looked humble, and made up my mind to do exactly the
contrary. At present I am preparing a stock of wisdom
to travel with. What think you of this Arab proverb to
begin with—' *Ne jouez pas avec les chiens; ils se diraient vos
cousins*' ? "

From Marseilles he wrote to his sister—

" MARSEILLES, *Nov.* 24, 1853.

" By getting up early, I have half an hour before half-
past seven, so I will write you a few lines. I am very
much obliged to you and my mother for your kind letters,
which I received at Avignon. Lyons is a fine city, and the
view, in good weather, must be magnificent. It is built
on high, rocky hills, on a tongue of land at the junction

of the Rhone and Saône. Hills as high as the Welsh
mountains surround it; and in front the plain stretches
out, I believe, to the Alps, sixty miles distant. The scenery
is beautiful; every here and there a gap in the hills shewed
the snowy Alps from afar, towering over everything; and
the sun gleaming on their white ravines, between the bands
of cloud, seemed a glimpse of a purer, fairer world than
the dull one which surrounded me. The hills here are
covered with vines and copsewood, and have long and slop-
ing lines, but as I got south they became gradually more
bare, jutting up in most picturesque crags. Approaching
Avignon, Mount Ventoux towered high above all, like the
back of a huge elephant among a flock of sheep; but, though
near us, the atmosphere was so thick that we could scarcely
distinguish it from the piles of white clouds, except by its
more regular outline, and the more systematic arrangement
of its snowy ravines. Avignon is the first town I have come
to with a decidedly southern aspect. The high-peaked slate
roofs of the north are changed into nearly flat ones, covered
with pale greyish tiles, very deeply ribbed; and the houses
being built of light grey stone, everything wears a look of
decay, and seems to have put on the livery of poverty. The
hills around are formed of a white calcareous rock, very
broken, and almost bare—their grey hue only broken by
a little dusty mint, and a few prickly herbs, with some
olives and pointed cypresses, and stunted pines, wherever
a ledge or hollow allows a little soil to lie. The plain is
equally dun in colour, and dusty, covered with a sea of
rounded olive bushes, and a few cypresses, which, near the
cottages, raise their dark spires among the grey-green of the
olives. Avignon is a large, finely-situated town, with a high

plateau of rock at one end, where the old palace of the Popes rises like a fortress. The old ramparts are almost perfect, and there is a haughty grandeur in the lofty walls and heavy, square towers of the palace, crowning the town, which savours much of temporal power and pride ; but the Amphitheatre at Nismes surpasses all I have seen for massive grandeur."

CHAPTER IV.

EGYPT.

THAT is a memorable day to the artist when he first ex-
changes the north of Europe for an Eastern clime; when
he stands front to front with that mysterious Past, which
there, scarce disturbed by the modern spirit of progress,
seems to shut out the weaker Present; when he receives
into his soul that glowing atmosphere of which no canvas
seems capable, but without which he is well aware that no
student of his pictures can see what he saw, nor feel what
he felt. If too old to profit by the inspiration—even Sir
David Wilkie was not able to withstand its influence—
happy is the artist who is allowed early enough to go on
this great pilgrimage, and who, beholding its scenes through
no prescriptive medium, is able to observe truly, and to
give us, not what tradition told him he should see, but the
very picture which the Supreme Artist shewed to him !

Such was the distinction which now awaited Thomas
Seddon. In his thirty-second year, free from mannerism,
full of hope and ardour, resolved to see only what was
visible, and to spare no pains in making it so to others,
he landed in Egypt. His letters and journals will tell us
how he employed his time. The tone of gaiety which will

be found to pervade them was eminently characteristic of him; but with it there was always mingled a deeper under-current of serious feeling. These made his society both welcome and valued by even his most casual acquaintances—a fact abundantly proved after his death by the testimony of many.

He left Marseilles on the 25th of November, and arrived at Alexandria on the 6th of December 1853. His landing was accompanied by the usual experiences of a first debarkation in Egypt:—

" *Dec.* 6.—We landed and went to the Custom-House through a sea of mud, and a chaos of boatmen, donkeys, and donkey-boys, shouting, ' Here, master ! him fine donkey !' ' Good donkey, master !' I mounted one, attended by my dragoman, who interpreted in a language which I have never discovered, but perfectly unintelligible, and a donkey-man, who spoke tolerable English, and conducted me through the most desolate streets, with deep channels cut across and along them—the people clad in ragged variety, every group a picture—to the great square, round which are the hotels and counting-houses of the Frank merchants.

" *Dec.* 7.—I went to see Pompey's Pillar. Outside the gate I witnessed a most painful scene. At the fountain by the roadside, where men and women were washing clothes, a Nubian slave, just brought from the interior, was standing stark-naked, sobbing piteously, while two men were washing him, preparatory to sale. One dashed pails of water over him, and poured it over his head, while the other rubbed him down with wisps of straw, exactly like a cart-horse, making him hold out his arms and legs, and striking him till he did, while the boys and men round

laughed and jeered at his misery. Immediately outside the
town is a large cemetery, and at the further corner stands
Pompey's Pillar, on a mound which seems like a mass of
brick rubbish. The pillar is impressive, from the enormous
size of its shaft, formed of a single block of red granite.
Its present object seems to be to immortalise 'G. Button'
and 'W. Thompson,' whose names are painted in letters
two feet high on the pedestal.

" *Dec.* 8.—The scenery of the Nile is much more beautiful
than I expected, especially near the junction of the canal.
On approaching Cairo, it becomes flatter and less wooded.

" *Dec.* 10.—Took a pencil sketch of the Pyramids from
the citadel at Cairo. Went to the fair to sketch subjects;
but was so surrounded that I found it impossible to do
anything; indeed, on leaving, after sketching two dervishes,
a stone was thrown at me. The story-tellers, and men read-
ing outside the coffee-shops, are very Arabian-Nightish.

" *Dec.* 11, *Sunday.*—Went to service in the English
Chapel; then walked to the ruined tombs of the Circassian
Memlooks, outside, on the east. These are very interesting,
and worth going to again.

" *Dec.* 12, *Monday.*—The close of the Mooled e' Nebbee,
or birthday of the prophet Mohammed, which has been
celebrated by the Saadeeyeh dervishes the whole of the last
week in the Usbekeyeh. This morning the sheikh rode
over the prostrate bodies of the fanatics. After wandering
about the fair with Fletcher, we met a Mr Burton,* who,
knowing the Arabic language thoroughly, has taken the

* Lieutenant Burton is one of a few Europeans who have succeeded
in performing the pilgrimage to Mecca. The published account of his
adventures is well known.

dress. Finding the door of the sheikh's house open, we went in, and found a great many Europeans there, with a crowd of Arabs, Kawasses, dervishes, and men and boys of all nations. Seats were ranged on each side for the Europeans. We came in at about eleven, and had to wait more than two hours before the sheikh arrived. During the interval, a number of jugglers and serpent-tamers performed their evolutions. Two men, very wildly dressed, went through some very bad sword-and-buckler exercise. Then men came in with pointed iron spikes, about fifteen inches long, with a large knob of iron at one end, garnished with short chains. These they stuck in the corners of their eyes, and twirled them round; then they dug the pointed end against their heads and bodies; then a man lay down, and they placed the pointed end on his stomach, whilst a man stood upon it; then they held four or five on the ground, point uppermost, and the jugglers walked on them; they then brought in skewers, and thrust them through their cheeks and arms, and through the flesh on their bodies, having stripped to the waist. The performance began now to be very disgusting : they foamed at the mouth, and seemed to become intoxicated, falling back into the arms of those behind them, apparently fainting. One man howled, growled like a lion, and raved like a maniac. This continued for some time, when the serpent-men came in with the asps round their necks; and then some of the fanatics rushed on the snakes, and tore them with their teeth; and when four or five men held them each, they struggled fearfully, and tried to bite them.* As

* He made a water-colour drawing of the following scene, and sketches of the several figures described above.

the banners now appeared, the lower order of them lay down side by side on their faces, while the others, better dressed, took them by the legs and shoulders, and pressed them closely together. By the time that a compact mass was formed, half-a-dozen turbaned dervishes, with long sticks, rushed in over them; and then the sheikh, on horseback, a man leading his frightened horse, who trod heavily and quickly, like a horse passing through a bog. He swerved, and trod on one man's head, and on the legs of others. The sheikh sat lying back, as if stupified and in pain, dressed in a huge green turban, and supported by a dervish on each side. Some of the men were lifted up as if hurt, and all seemed to be, or to sham an intoxicated ecstasy."

He concluded the year with a visit to Sakkara, of which we have an account in the following letter, begun in the Nile-boat, and finished at the place of his destination:—

<div style="text-align:center">

" On the Nile, en route for Sakkara,
" Dec. 30, 1853.

</div>

" My Dear E——,—I have been very glad of Lear's arrival, both because his advice as an experienced traveller has been very useful, and also because I have been able to consult him about the pictures I think of painting. He says that I have become accustomed to the language and habits of the people, and have settled down to work, in much shorter time than most persons, so my conscience is at ease. I have already painted a camel and Bedouin on a small canvas, 14 inches by 10 inches, which is finished, except the desert for a background,* and a portrait of Lieutenant Burton in full Arab costume, with a camel, for an

* This picture was afterwards purchased by Lord Grosvenor.

account he is going to publish of his travels in Arabia, and his journey to Mecca. I am just going to begin the interior of a very beautiful mosque, on a canvas about two feet by two feet six inches. When Hunt comes, I shall spend a week or two in sight-seeing in this living kaleidoscope, in which everything wonderful and queer is jumbled in rich confusion. Captain and Mrs P——, who are staying at the hotel, asked me yesterday if I would accompany them to Sakkara, so I am now on my way. They are a newly-married couple on their way to England from Ceylon, and will remain here a fortnight longer. Our boat has a sleeping room at the stern; a main cabin, on one divan of which I am writing; and a fore-cabin, in which we had a pic-nic tea on the divan—not possessing a table—at which our hostess, a very agreeable little lady, was much amused. At about five o'clock the sailors squatted in a circle round a dish of oatmeal, &c., and helped themselves with their fingers out of the dish, taking alternately a bite from a turnip. When it was cleared away, two of them played, one on a sort of drum made of earthenware, with parchment stretched over it, and the other on a reed pipe, which sounds exactly like a bagpipe; and they sung songs, all joining in the chorus. One song they accompanied by clapping their hands in time, and at the end of each verse they gave a fine howl, in which one or other of the donkeys continually joined, provoking responses from the shore. Our boat contains the reis, or captain, and eight crew; ourselves, with five donkeys and donkey-boys in the forepart, and Suleyman, the dragoman (interpreter), who talks very funny English. He has just told us that he did not give up ' him mutton at tea, because him mutton want to stop till to-morrow, because him eat

c

him up at breakfast.' This, by the way, is a favourite style here. Lear asked a donkey-boy about crocodiles, who said, Him coming up the river; him eating up a great many peoples.' The banks near Cairo were very beautiful before and after sunset; the picturesque palm-trees, and long, sloping yards of the boats, looking black as night against the red golden sky, and the silhouette of the figures cutting sheer against it. Nothing can look more graceful than the Fellaha women walking along the river with their jugs on their heads."

"31st.—I resume my narrative. About a mile from the river we came to Mitrahenny, a village built on the site of Old Memphis, where a huge sphinx lay on its face in a pit now nearly full of water. All round were masses of granite, the broken fragments of columns; and the French have sunk square pits between the palm trees every few feet, to seek for remains. After going about two miles along a raised causeway, half destroyed by the late inundation, we came to the foot of a long range of sand hills, on which stand the pyramids. On the summit of these hills was the burial-ground of Old Memphis, and human bones and skulls, blanched in the sun, lie in every little hollow. The place is perfectly desolate, and lies in a succession of mounds. Every here and there a pit has been opened, and the remains of mummy cloth lie about, with bones, &c. In one of these pits lay a very handsome basalt sarcophagus, with the lid sculptured into a human form, and covered with hieroglyphics.

"The pyramids are almost ruined. The largest is now like a series of steps, all the stone having been taken away, and the core only left. Seven or eight smaller ones lie along the top of the ridge of hills; and away in the valley,

at the end, you see the tops of the great pyramids of Ghizeh. The most interesting thing, and what we came to see, was a tomb discovered last year, and which is now being cleared by the French Government. The entrance, as is always the case with these pyramids, is at the bottom of a square shaft, sunk some twenty or twenty-five feet; having passed which we came to a long gallery, at the commencement of which were tablets fastened into niches in the walls, and covered with inscriptions. After going about eighty yards in this gallery, which is vaulted, and ten feet wide by fifteen feet high, we came to a cross gallery, where, at intervals of five or six yards on each side, were vaults, sunk some five feet below the level of the gallery, and in each a huge sarcophagus of single blocks of granite or basalt, most of them plain, but two with hieroglyphics. They had been rifled of their contents, probably by Cambyses and the Persians more than two thousand years ago. There were thirty-two of them. The men brought us some pots from the mummy pits, with ibis mummies; but, when opened, the birds fell to powder.*

" Yesterday it was so hot that I felt the sun through the umbrella and a turban I had wound round my wide-awake. I have not seen many insects here, but it is not the season yet ; there are many of the Painted Lady and Red Admiral butterflies. The Cairo donkeys are much more spirited than those at Dinan; they go off at full gallop, donkey-boys

* " The Arabs know very well where the tombs are concealed. It was from them that Mons. Mariette was told of those at Sakkara. An Arab told Mr Masharra that he knew where there were several tombs at Fagirun; and that if he could get a firman he would shew them to him, and they would share what they might find."

and all. I have ridden on a camel; it is like riding on a swing twenty feet from the ground."

A few days afterwards he was again at Cairo, where the following letter is dated :—

"*January* 8, 1854.

" I have this week begun a study. In Ibraheem Pasha's garden there is a white marabout's tomb, with a mimosa tree over it, and three fine palms ; on the other side, a hedge of fine cactuses. Some ropemakers in blue gowns and white turbans, and their boys, are always at work there, and, with the little figures, I think it will be pleasing.

" As another box has arrived from Hunt to-day, I really expect him next week ; so I shall postpone beginning a larger work till then, so as to have his advice on the best points of view. I shall also begin to-morrow a sketch of the citadel, which stands at the end of a range of limestone hills, looking down over all the town, whose minarets and domes lie along its feet. In the afternoon, shortly before sunset, the rosy light on it and the mountain range, with the exceedingly blue shadows, gives a beautiful effect; while in the middle of the day it seems colourless and shadow-less. It is curious how completely scenes which are lovely by afternoon or early morning light lose all charm in the bright sunshine. The country and buildings are principally mud or sand coloured, while the glare of the sun makes the green trees (and palms especially) look quite grey. On the other hand, towards evening, the tops are bathed in rosy light, whilst the bases of the buildings and hills are half lost, and melted into light blue mist.

"I think that I shall have no difficulty in inducing people to sit for painting, now that I can talk to them. I am afraid that I shall hardly do as many pictures as I hoped; but I already feel that I am improving very much in painting, and especially in figure-painting, which is important. The irregular troops who form escorts, and are a sort of country gendarmerie, are the most picturesque-looking cut-throats you ever saw, dressed in ragged finery, as many-coloured as the rainbow. I think of painting one of them on horseback with his long gun and two brace of long pistols (most dangerous weapons to the firer), and a knife or two in his sash. The young Pasha has been exercising some twelve thousand regular troops the last few days, just outside. I rode out to see them one morning, but they were resting that day. They are very fine men, and well drilled. The Indian officers here think that if the Sepoys were not officered by Europeans, they would beat them.

"The horses here are good, but spoiled by their putting them into full gallop and pulling them up short in ten yards, and twirling them about; and the saddles of the fine gentlemen are most absurd affairs, weighing I do not know how much, being covered with plates of silver gilt. Ayrton Bey, an Englishman here, told me there are a hundred and twenty solid silver crescents and wheat-sheaves on his housings, and they are so badly put on that he cannot afford to go fast when he uses that saddle; for a gallop in the desert would rattle half of them off. Then there are thirty or forty bullion tassels on the martingale or head-stall, and on the horse's back, behind the saddle, a piece of worsted-work embroidery of all imaginable colours; and so, with all this finery, they go caracolling like rocking-horses through

the town. The donkeys here are the gentlemen. I was
quite surprised to learn that for a good one forty, fifty, or
sixty pounds is no uncommon price."

From the British Consul-General, the Hon. F. Bruce,
our traveller experienced unceasing kindness during his
sojourn at Cairo; and his evenings were often delightfully
spent amidst the society assembled under a roof which so
well represented English hospitality. Nor were his obliga-
tions to Mr Lockwood less. His fine library was placed at
his disposal, as well as a Syrian pony, on which he took
many excursions in the neighbourhood. Mr Lockwood's
house had once belonged to the Coptic patriarch; and
one of its apartments, with trellised windows, and with
panels inlaid with ivory, supplied a tempting subject for
the artist's pencil. In the houses of these and other friends,
as well as in his own hotel, he made the acquaintance of
many excellent and accomplished people, and also saw
some amusing traits of English character. In one letter
he says:—

"I like the old Major. He came back on Friday from
the Pyramids, saying, that of all the impositions he had
ever heard of, they were the greatest; and that people who
cry them up, and induce others to come all the way to see
them, are greater asses than those they ride on. Such was
his indignation, he would not go to the top; however, he
knocked off a piece, and also a chip from the Sphinx (not
the remainder of the nose), to add to his collection of relics.
I hope he will not go to Italy; the Venus and Apollo would
each lose a toe. You will wonder what that horrid brigand
on the first page of this letter means. It is an attempt

to portray myself as I walk about in the sun, a kufeeya wrapped round my head, with a crimson-and-gold striped handkerchief, and innumer-able small tassels dangling from it. To avoid annoyance from the boys, I have locked up my wide-awake, and donned a tarbouch; and having now a very respectable beard, I pass current for an average Mussulman."

Towards the end of January he writes:—

"We at last had half-an-hour's rain one night last week, and to-day it is cloudy and cold. We have had one or two fine sunsets last week; and I have begun a small sketch in oil of the town lying at the foot of the range of rocks, whose tops are gilded by the glowing sunlight, while the town is half-smothered in mist. Yesterday my patience was sorely tried in painting a vicious black camel, who would do exactly the contrary to what I wanted. I wish I could get one of the Pasha's well-bred dromedaries; they are quite different creatures from the common ones. He passed through the town to-day, with a splendid Arab horse led behind his carriage, and followed by two first-rate dromedaries, splendidly caparisoned. I think I shall ask Mr Bruce to tell the Pasha that he wishes a picture of one, and then he might send me a good one. The great difficulty here is to paint any well-bred men or animals:

first, it is against their creed; and, secondly, they are afraid
of your bewitching them with the Evil Eye. You see rich
natives with their children shabbily dressed, so as to avoid
attracting notice.

" The French party I mentioned left on Friday, to go up
the Nile. They joined their boat at Old Cairo. One of
them was sketching in the street, when the hotel-keeper saw
their servant go up to him, and quietly take all the contents
out of the pockets of his coat, and bring them to the boat,
without saying a word. Mr Williams asked him what he
was about, when he said he thought he might as well take
care of the things himself as let the rascally boys run away
with them. ' Look at him,' he said; ' he does not know
anything about it. Anybody could have taken them.'

" Mr B―― related at dinner an anecdote to shew the
contempt of the Chinese for death. When he was in China,
three robbers had been arrested, and were put into a cell
in the guard-house; and in the morning the keeper came
to say that they had all three hanged themselves, and
wished him to come and see them. He went, and found
the cells occupying the sides of a large room, and opening
into a corridor, where a policeman walked up and down all
night. The only thing in the cell was a pail, and they
were constantly visited by the policeman, who looked in at
the door. The window was a small round hole, seven or
eight feet from the ground, with an iron bar across it.
They had turned the pail over, and tied a noose round the
bar. One then got up, and hanged himself; the others
then took him down, and laid him upon the floor. The
second did the same; and the third, after taking him down,
got up and put his head in the noose, merely slipped his

feet off the pail, and died without a single movement, for his legs were hanging on each side of the pail, which was not kicked over. When Mr B—— went in, he saw there the three fellows, who had written some verses on the wall, to the effect, that, having been captured, the Flowery Society would not receive them again, and so they had resolved to die. This they had done so noiselessly, that neither the prisoners in the next cell nor the keepers had heard any movement."

"*Tuesday Evening, Jan.* 30.

"At last we have a cold day. It is quite odd to see the Cairenes curled up with their gowns over their heads, and looking a dirty blue colour. It is the high wind which makes it feel cold, and which has prevented my painting out of doors. However, I have got a rather handsome Arab—a Syrian, from Bethlehem—to sit to me to-day. He is a respectable man, a merchant. I shall have to be magnificent, and shell out two shillings per diem. He is dressed in a plain coloured silk kooftan, or long gown, with a blue cloth robe, and a black loose gown with the corners embroidered, one of which is thrown over his shoulder. His head is very handsome, with thin aquiline nose and high forehead. I saw him passing, and asked Mr Williams to speak to him. He said to me he thought he was from Bethlehem. He says you may see two hundred men from there, and that they all have the same features; and among the tribes of Nubians there is the same resemblance.

"I heard a capital story on Friday evening, at Mr B——'s, of a dandified *attaché* at Constantinople, who travelled into Koordistan, intending to copy Layard, and write

a book. He was what he called *roughing* it, with six or
seven horses carrying his necessaries; *i. e.*, a few things he
could not possibly do without. Among them were the
wooden frames for cleaning his boots and shoes, and a case
of bottles, of a peculiarly fine varnish, for his polished
leathers. He was attacked by the Arabs, who overhauled
his kit. When they came to the bottles, they opened them;
and the varnish being made with Madeira, and scented with
all sorts of good things, it smelt so nice that the thieves
thought it must be something to drink. In vain did he
explain that it was paint for his boots. They were sure
that it was too delicious for that; and, in order to try, he
should drink some : so they took out one of his own cut-
glass tumblers, and made him drink a glass of his own
boot-varnish !

"It is nearly three months since I left you. Before the
end of the summer, if I shall not have done all I wish, I
hope I shall have improved a good deal. I already paint
more surely and quickly; and, with Hunt's assistance and
advice, *vous verrez*.

"I took up Keble's 'Christian Year,' the other day, to
turn to some of those we have read together, when I was
very much struck with the one on the forms of prayer to
be read at sea, which I had never read carefully before.
'The wild winds are rustling in the quivering trees' to-night,
indeed. Do you know it? Is not the last verse beautiful?—

> " ' The eye that watches o'er wild ocean's dead,
> Each in his coral cave,
> Fondly as if the green turf wrapt his head
> Fast by his father's grave.
> One moment, and the seeds of life shall spring
> Out of the waste abyss,

And happy warriors triumph with their King,
 In worlds without a sea, unchanging orbs of bliss!'"

"WILLIAMS' HOTEL, CAIRO,
 "*Feb.* 11, 1854.

"DEAR E——,—Mr Bruce has left me the 'Arabian Nights,' which I have been conning; but my present idea is to paint Abraham's servant, Eleazar, waiting at the well for Rebekah, standing in the middle of the kneeling camels, with the Bedouin drivers lying on the ground. Do not think me very changeable if I alter my intention; for I tell you my projects as they pass through my brain.

"We intend, in seven or eight days, to take a tent and two camels, with their drivers, and a servant to cook, and camp out by the Pyramids, and move quietly to Sakkara. By this plan we shall economise our hotel bill, and the camels, which will be necessary for my picture, will also be useful to travel on; and we can move some seven or eight miles a-day if we like, and see the country, without losing the sunrises and sunsets, so extremely beautiful here, and which, with our town dinner hour at half-past six, are completely lost now. In case we go to Sinai, too, we shall learn what things are necessary for the journey.

"There are great difficulties in painting in Cairo. To a mere visitor there is the difficulty of seeing the natives in private. The Europeans live here twenty years and know nothing of them. Any one who could take a house and remain two or three years would make a great reputation— at least, he would have the power of doing so; and by inviting native gentlemen, you would go to their houses in return. Hunt and myself dine to-day at Mr Bruce's, and

to-morrow we are going with him to call on the Shekh-el-islam, the head of the Mohammedan religion here. It appears that his house is one of the handsomest in Cairo.

"I have changed boys a few days ago, and have now rather a character, known as 'Hippopotamus Jack,' as my running footman. I complained of the extreme simplicity of his attire, which he apologised for, saying that his wife had run off with all his clothes to Dongola, up the country. He went to England with the hippopotamus, and, among other virtues, is a snake-charmer. He says that 'this Egypt no good; plenty money in England. Queen Victoria gave me two pounds, and the gentleman that marry the Queen a pound, and the Sultan of Paris and his wife a pound.' His stock of English is limited; and when he does not know a word, he says, 'Me not got him.'

"Since I wrote last I have been over some mosques. The Ashar, which is the university of Cairo, is extremely curious. I have sketched the plan. You enter a small court, through a double gateway, into a large square court, as large as your good doctor's garden. There is a colonnade all round, under which are groups of boys and young men seated round their masters, while hundreds are crossing the yard in all directions, and making an immense noise, as in an English playground. On the opposite side of the square you enter an enormous room, supported on rows of columns, in which there must be some thousands, all seated round their masters, and learning their lessons out loud, and rocking backwards and forwards the whole time. They are arranged according to nations, and the variety of costume is most picturesque. In one part are the Nubians, in another the wild Arabs of the Hedjaz, Syrians, Morocco-

men, and Mussulmen from India. The elder men are very
polite, but the younger ones are dying to pelt you—in fact,
you are obliged to have men with long sticks to keep the
boys off, or they would play you some trick; but two thou-
sand turbaned boys, in every variety of colour and costume,
make a most wonderful spectacle. A plentiful supply of
whitewash makes the place very healthy, but covers up the
architecture. The ornament in part of this and other earlier
mosques is extremely like that of the early Gothic in
Europe. The doors in most of the mosques are exquisitely
worked in brass. In the great mosque of the Sultan
Hassan, the door leading to his tomb is covered with bronze
ornaments, inlaid with silver, as exquisitely as the finest
jewellery; and the walls are covered to the height of twenty
feet with mosaics and carved ornament, but so covered with
dust that few people find it out.

"I also went to the old Coptic churches last week, at
Old Cairo, the Babylon of the Romans, where some say St
Peter wrote his epistles. They are excessively curious and
old, but very difficult to describe, being separated by screens
into several divisions. The three semicircular apses at the
top are partitioned off by wooden screens, richly panelled
and inlaid with ivory; the right-hand one has three rows
of marble steps, upon which the bishops sit in conclave to
choose their patriarch. The centre apse serves for the con-
secrated elements; then a space, in which there is a reading-
desk, is again railed off by an open wooden railing, and the
centre part has railing from pillar to pillar; and on the left-
hand is a very curious old pulpit of inlaid marble, supported
on pillars, and with stone stairs at one end. On the screens,
especially at the end near the altar, there are numbers of

paintings, principally of St George, St Michael, and the
Virgin. The latter is held in great reverence, though the
present patriarch is suspected of want of loyalty. He was
Principal of St Anthony's in the Desert, and is a superior
man. Some time ago he was performing service, and the
picture of the Virgin was surrounded by candles, one of
which fell against it, and set it on fire; the priests were
rushing forward to save her, when the bishop stopped them,
saying, 'Stay, stay; she is quite able to save herself' (the
picture being supposed to have miraculous power). Under
one of the churches they shew the place where the Virgin
and the infant Saviour were concealed when in Egypt. It
is a place like an oven, about three feet high—in fact, a
small hole cut in the rock. I believe their service is very
curious. They hop about on crutches, and make a terrific
noise with cymbals ; besides which they read the service in
Old Coptic, a dead language, understood neither by priests
nor people."

" *Monday Evening.*—To-day we all met at Mr Bruce's,
in order to visit a celebrated apartment in the house of the
Chief Judge of Cairo, or Sheikh of the Mufti. We were
accompanied by a most amusing old gentleman, named
V——, the interpreter to the Consulate. It is certainly
the most beautiful room which I have ever seen; very rich,
and yet ornamented with a delicate taste, that one looks
for in vain in the barbaric splendour of England or France
at the time of Louis XIV. or XV. I have drawn the plan.
There are two large transepts, like those of a church, fitted
up with divans, and a smaller one at one end, all three
having the floor raised six inches above the centre part; in
the middle of which is a basin sunk in the ground for a

fountain, which, together with the whole floor, is of richly inlaid marbles; and in the centre of each end, opposite each divan, there is a recess, the top of which is worked into dropping pendants, like stalactites, while the *fonds* is beautifully inlaid. Below there is a sloping slab of porphyry, with little inlaid steps of marble on each side, down which the water trickles, while it flows in one broad sheet over the slope in the centre. I cannot imagine anything more delightfully cooling, both in reality and in appearance, than these in hot weather. The walls of the room are lined with porcelain tiles to a height of seven feet above the ground, and in the centres, over the divans, are elaborate panels inlaid with ivory. The windows above are of stained glass, the most beautiful I ever saw. Instead of being an attempt to imitate pictures, they are formed of separate pieces of glass, set in a framework of plaster, in the shapes of flowers, each leaf and petal being of a different colour, and looking more like jewellery than glass. The ceiling was very richly ornamented with gold, and decoration very much like that upon the finest Indian shawls. If Hunt does not paint this, I may possibly do so; at any rate, I will make a sketch, if I can. There is nothing gaudy in their ornament; it is all upon the same principle as their rich shawls and carpets.

"The hotel is now quite full, as the boats are returning from up the Nile, and the people are preparing for Syria. We have four Americans and a dissenting preacher, who are most amusing. The Americans have been trying to see who will take them through the fastest and cheapest. They think two days at Jerusalem a great deal too much, while the dissenting parson fights manfully for a week. The

Americans boast of having made the quickest journey up to the first Cataract this year. They did Thebes in two days and a half; and they say that an industrious man may do it easily in two! They seem to look upon life as a steeplechase. There is also a very gentlemanly, quiet man, Mr Nicholson, an Englishman, who went up for his health, and has returned but little better. I very much doubt if he will ever leave the hotel alive. It is very sad to see him so near to death's door, and none to help him or be with him. There are several men at Cairo who seem to have come there as a last hope.'

CHAPTER V.

THE PYRAMIDS.

As it was deemed advisable for Mr Nicholson to remove, for a change, to the plateau of the Pyramids, but as it was too evident that his days on earth were drawing to a close, Mr Seddon determined not to leave him; and he and Mr Hunt proceeded to the Pyramids, and pitched their tent beside their dying fellow-countryman. The disinclination to dwell upon the description of his own feelings, which always characterised him, and the omission of such passages by the editor as appeared to him of too private a nature, are the causes of the apparent abruptness in the transition from a serious tone to one of a gayer mood, which may be noticed in the following and some other of these letters:—

" In a Tomb at the Pyramids,
" *Feb.* 1854.

" My dear E——,—I must explain the date of my letter, and account for my residence here. First, there is a poor fellow here—a very gentlemanly man, named Nicholson— who came to Egypt suffering from an attack on the lungs, and who has come here for a change of air. I fear he is sinking rapidly, and as he is quite alone, I thought I would come and do something here, so as to be able to assist him

D

in case of need. So we have brought the tents and canteen, which we shall want for our Sinai campaign, and we are bivouacking within a hundred yards of the Pyramids, close to poor Nicholson, who came yesterday week. He sleeps and dines in a tomb, which is a comfortable square room, twenty-five feet by fourteen feet, and about six feet high, cut in the solid rock. He has a tent pitched just outside, where he sits during the day. We live entirely in ours, which is pitched ten yards off, close to the Sphinx, as we wish to see what will be indispensable for our great expedition.

"We have a double-pole tent, with double roof, which, being stretched one six inches above the other, prevents its becoming intolerably hot with the sun on it. It is about twenty feet long by ten feet wide; and though it narrows up, it gives us a grand space between the poles, and is much more comfortable than the ordinary single-pole tents, where the centre is filled up by the pole. I have drawn you an elaborate ground-plan. Opposite the door, in front of the pole, stands a leathern water-bottle; and on each side of the tent a tin washing-basin. Matting is laid between the poles, and one side is Hunt's, and the other my territory; and beyond the second pole is a general receptacle for boxes, &c. As we have determined to do without beds, I have bought a long striped blanket of camel's hair, seven feet wide, and about thirty feet long, which, when folded up, will, I believe, be very comfortable when I am accustomed to it; but having had only two nights' trial we are not yet hardened, but are only arrived at the stage when every projecting angle of the body feels severely bruised. The first night we neither of us slept a wink; but last night, though Hunt was as miserable as ever, I managed an hour or two's sleep. This was in spite of a violent storm of wind,

which I expected every moment would blow the tent clean away, and which covered us with a thick coat of sand, which we are obliged carefully to remove from our eyes before opening them. However, early in the morning, one of the small tent-pegs gave way, and while ' Hippopotamus' was driving it in again, a gust came in and tore up the whole of Hunt's side. You would have laughed to have seen Hunt and myself rushing out in our night attire—he looking grave, and holding on like grim death to the skirts near him, while I was roaring with laughter, and holding on at the ropes outside. At this juncture I saw Nicholson's servant driving in the pegs of his master's tent, when all at once his main rope cracked, and in half a second he was throwing himself frantically on its prostrate remains, to prevent its going back to Cairo alone, after one of my yellow slippers, which flew away upon the wings of the wind. By driving in double pegs, and having strong ropes and iron pegs to windward, we escaped this fate. All day the wind has continued, the clouds of sand looking like a dull yellow mist. A green veil, which I had tied fourfold over my eyes, was blown nearly perpendicularly, till it looked like a bird at an enormous height, and then it blew straight to Sinai, where I hope to find it.

" Fortunately we have had our meals in Mr Nicholson's tomb, and have only swallowed a moderate quantity of sand. We dine upon a regular Arab table, which is a round piece of black leather, with a string let through it all round, so that it is laid flat upon the ground, and when taken away, the string draws it up into a bag, with all the crumbs in it; and when we shall have accomplished squatting *a la Turque*, we shall get on very well, but at present I cannot manage more than five minutes of the truly polite attitude

without getting pins and needles in my feet. Hunt has engaged a very nice man indeed, who speaks English well, and works capitally. My ornamental servant, 'Hippopotamus,' I have rigged out in a blue blouse and white Turkish drawers, and having had his head shaved, and almost induced him to use soap, he is magnificent. Gabriel, Hunt's man, had some prejudice against him at first, but, after three days' acquaintance, pronounces him a capital fellow, who will do as much work as three lazy dragomen. Every evening he gets a large circle of Arabs, and keeps them in a roar of laughter with stories about his travels in England."

" *Tent, Monday Evening.*—A high wind blowing makes the tent rather cool for sleeping in; however, we managed the half of last night, so I have great hopes of becoming sufficiently hardened to-night. I must say that both Pyramids and Sphinxes, in ordinary daylight, are merely ugly, and do not look half as large as they ought to look, knowing their real size; but in particular effects of light and

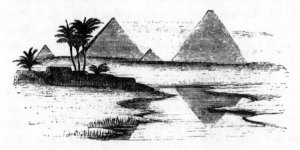

shade, with a fine sunset behind them, for example, or when the sky lights up again, a quarter or half an hour afterwards—when long beams of rose-coloured light shoot up like

a glory from behind the middle one into a sky of the most lovely violet—they then look imposing, with their huge black masses against the flood of brilliant light behind. There is a pool of water about a quarter of a mile off, where you can see them reflected; and there I think of attempting something. They are quite on the edge of the desert, being on a ledge of rock about a hundred feet high, and with five hundred yards of sand between them and the green fields; and on this debateable ground are innumerable irises of a lovely violet, of which I shall bring back a root or two to adorn your drawing-room next spring. The ground all round is honeycombed with tombs, many of them square pits sunk sixty or seventy feet in the solid rock, not very safe things after nightfall; in fact, the Pyramids stand in the centre of an ancient burial-ground.

" I have just been stopped by a violent fit of laughter. I had called 'Hippopotamus' (who sleeps in a tomb close by) to close the entrance, and as he heard the hyæna last night, I asked him if he had heard him to-night; and while he was answering, without thinking at all about it, I growled. Instantly Hippo called out, 'Him there!' and ran off to the tomb as fast as possible. I shouted to him to come back, but poor Hippo was too frightened, and answered from inside his tomb, 'Nò, no; him come now to eat me up,' which nearly killed Hunt and me with laughter; and no threats or persuasions could make him move. For some time he would not listen, but kept exclaiming, 'Him one very bad fellow; him want to eat me.'

" We have no news from the seat of war, and the only effect of it is to make the English and French very popular with the Musleim."

In the following long letter to his brother, we have the closing details of that labour of love, which was afterwards to be repaid to himself, through the remarkable providence of Him by whom the " cup of cold water" is not forgotten. The notices of Cairo will also be interesting to many readers :—

" *March* 11.

" DEAR JOHN,— . . . He has been rapidly getting worse, and I could not bear to let him die alone, with none but an Arab servant; so I have begun a sunset view of the Pyramids, in order to be on the spot, and keep him company. After making a few sketches on Monday, to select a good spot, I have decided on a view with a village and palms in the left of the foreground, and à sedgy pool of water in which the Pyramids are reflected. It is no easy matter though, and I fear for the result. For the first three days I have worked without seeing any sunset effect, as we are now having cloudy and windy weather, which is likely to last till the equinox.

" Poor Mr Nicholson was so ill on Monday, that I wrote to Cairo for a doctor. Major B—— kindly came with him the next day; and he was moved to Cairo, whither I followed two days after, intending to return after the clouds dispersed a little, and after I finished the foreground of my camel sketch, which I may perhaps send to England by Lear. Altogether, I am very dissatisfied with myself this last month; and the weather has been so extremely windy and cloudy, that I long for the sun again. . . . Nicholson, I fear, has now only a few days to live, and knows it, and is, I think, quite prepared. Though very reserved in speak-

ing of himself, I think he talks more to me than to any one.
Yesterday he asked me about my illness, and if I expected
to die; and quoted several hymns, which I read to him
from the hymn-book, and Lyte's 'Abide with Me,' which
he liked very much. It brings back all my own feelings
in my illness to my mind; and it is a good thing to be
reminded of thoughts and feelings which the busy world
buries under a mass of idle frivolities, and worldly anxieties
make one forgetful of deeper and more important interests:
for, indeed, I am very anxious, when I see that I have staked
another's happiness or comfort on the result of my exer-
tions. My poor E——, if I should fail! I try to feel that
I have not acted thoughtlessly and rashly, and certainly I
thought at the time that I sought God's guidance; and if
I did so really and truly, then I do not doubt success even
in this world; but if I deceived myself, and thought it
God's will because it was my own wish, then I do not
deserve it.

"In this quiet nook, nobody talks or thinks about the
war, except when the English newspapers arrive, or when,
every now and then, there is a report that the united fleets
have entirely destroyed the Russians at Kalafat.

"This country is a spectacle of a society falling into
ruins, and the manners of the East are rapidly merging
into the encroaching sea of European civilisation. The
people themselves seem scarcely to understand how it is
that the Frank is greater than the true believer; and yet
they know it is so. But Egypt is like a dead nation;
neither taste nor manufactures exist. Their recent build-
ings are the vilest possible copies of European ones, mostly
planned by ignorant Italian refugees, and not a single thing

shews the slightest taste; and yet the town is full of mosques and buildings shewing most exquisite taste, but all falling into ruin and decay."

"*Wednesday, 15th.*—I get on rather fragmentarily, for I can scarcely find any time for writing. The last two or three days, Nicholson has grown so rapidly worse that every spare moment has been spent by his bedside, where I have been trying to repeat the kind advice that I received during my own illness. I very much doubt his lasting through to-day; and he is such a nice fellow, so patient and so uncomplaining !

"And now as regards Cairo. It is certainly a wonderful kaleidoscope, and has all its beauties and some of its inconveniences. First, its narrow streets, so bustling and picturesque, are as inconvenient to paint in as Cheapside. The dust and crowd make oils impossible. The religious prejudices of the people make it difficult to persuade any respectable person to sit, and especially at an hotel; and they are so horribly lazy, that they will not make the exertion. With a private house, and residing here, the thing may be managed—and had Hunt come out with me, we might easily have arranged it; as it is, he is in despair at the difficulty of getting any women to sit. There is, doubtless, much beauty in the architecture; but I confess that it is so different from that which is required in Europe, that I doubt the expediency of an architect's coming here. As in Europe, so here, it is only the old buildings that are grand, and there are very few of them. The style resembles much the Romanesque : the double or triple semicircular-headed window, with a circular hole or holes in the spandril, is very constant. In the earlier buildings such as the

Iayloon mosque, the piers and arches are very massive; and a flat ornament, like lace-work, is carried round all the openings, very similar in character to the work in Romanesque and Norman buildings, and circular windows, of small geometric patterns, are introduced in the spandrils. The grandest thing in Cairo is the door to the mosque of Sultan Hassan, which is treated on a totally different principle from those of our churches. A recess is carried up to a height of full one hundred feet, and the doorway is placed in it, with steps leading up from either side: this gives great height and grandeur of effect. The doors to the mosques are many of them extremely beautiful, being covered with bronze ornaments in relief. They employ Mosaic very beautifully in the older mosques, as also coloured tiles in the interior both of houses and mosques. The Cairo minarets are very beautiful—much more so than the needle ones of Stamboul—and there are two of the city gates which are very grand and imposing; but everything is built of such perishable material, and so utterly neglected, that there is little that is good remaining. Most of what looks so picturesque in painting is merely daubed on with a brush, and red, white, and black wash.

"The last three days there has been an illumination here, in honour of the betrothment of the Sultan's daughter to the Pasha's son, and the town really looks very picturesque. All the shops in every street are decked out with their handsomest things, and the walls are hung with carpets, shawls, and draperies; or, if the owners are too poor for this, an old coat, once handsome, or a tablecloth does duty. At night all the shops are illuminated, while the masters are seated with their friends around them, smoking and

taking coffee. One street (the streets, you must remember, are only about two yards wide), where the Pasha's private treasurer lives, has coloured awnings over it; while light wooden arches, thrown from house to house, and covered with lights, make it look like an arcade, the walls all down being covered with lamps, and chandeliers suspended in the middle of the street. The master of the house has hired an orchestra, who play every evening—the effect is really beautiful. Some of the pashas have also illuminated the whole wall of their palaces, and often the whole street in front of them. The order and good temper of the people are something wonderful to those who know a pushing, noisy, European crowd; and long strings of eight or ten women, like great black clothes' bags, or silk balloons, on donkeys, preceded by a very grand black eunuch, and the rear brought up by another, followed by most bumptious blackies, are threading their way through the crowd. In fact, it must be a grand field-day for the ladies, who are out in shoals this evening.

"Lear has just returned from up the hill, to my delight, and we shall carefully reconsider our plans. Do not be surprised if they should be somewhat modified. Give my kind love to all, and believe me your affectionate brother,

"THOMAS SEDDON.

"*P.S.*—Poor Mr Nicholson died at two this afternoon. At ten in the morning I was alone with him, reading a few verses, when he had such an attack of suffocation from

phlegm, that he seemed to be sinking, and I thought he was dying in my arms. He never rallied, but retained his faculties till the last. I read a few hymns and verses at intervals, and after a short prayer he said, 'Lord, have mercy on me;' and then to me, 'I believe He will,' and afterwards, 'It is very hard to bear—patience and perseverance;' and after holding my hand almost all the morning, he died peaceably, and without a struggle, and I believe and trust has passed from misery to glory."

"CAIRO, *March* 15, 1854.

"MY DEAR E——,—I feared I could not have written by this post; as it is, I can only send you a hurried letter, for since I last wrote all my spare time has been given to poor Nicholson. For the last week, whenever I have offered to read anything, he has wished to hear the Bible. He asked me if I had expected death during my illness. He was a very nice gentlemanly fellow, and so patient, though his cough was most distressing. I have had to settle all his affairs for him, which has taken up my time very much; but I knew you would be the first to wish me to do so. It is very painful to see a man dying among strangers, far away from all his friends; though, in fact, he had every comfort he could have had in England, and the gentleness and care of his Arab servant (who spoke French) could not be surpassed. I followed him to the grave to-day, in the English burial-ground, which is a large square, like that at Dinan, but kept so beautifully, with beautiful trees, and not a single weed.* There is a fine avenue of cypresses down the centre, and two very fine

* It is in this same spot that his own remains now rest.

pepper trees, with drooping feathery foliage, on each side, and other ornamental trees and flowers. I often used to think, while reading or sitting by his bedside, that the office you had intended to have performed to your poor sister-in-law had been transferred to me ; and it was well to be reminded of the thoughts that had impressed themselves on my mind during my illness, and which returning health and hopes were gradually making dimmer.

. . . "The day after to-morrow I intend to return to the Pyramids, where I have begun a view of them by sunset, with a village on the left, and a sedgy pool of water, in which they are reflected. I shall try my best, but the difficulties are so great that I shall not be surprised if I fail ; for, first, the weather is now so cloudy, and there are so few good sunsets, and then the effect is so transient, that it fades as you look at it, and half an hour after it is dark, and you are not able to paint till next day. If I succeed, I think it will please.

"Lear returned to-day from Upper Egypt. He gave up oil painting, and has brought back an enormous number of sketches, which are exceedingly interesting. He wears a straw hat, with a brim as large as a cart-wheel, with a white calico cover. He was called up the Nile, *Abou lel enema el abiad zèidy soufra;* which being interpreted means, the father of the white turban like a table. He has already been to Sinai, so I shall consult him thereupon."

The Sunset View of the Pyramids was eminently successful. No one who has seen it will readily forget it. With its intensity of solitude, and with the daylight departing from those solemn memorials of human grandeur and frailty,

it is a sublime poem, and the spell deepens as we gaze.
Soon after the author's death, it was thus noticed in one of
the leading literary journals:—" Our readers will remember
that we especially drew their attention, some time since, to
the 'Sunset behind the Pyramids,' as a picture of singular
beauty. Connected with this very beautiful work of Art is
a little history, which, now that Death has placed his seal
upon the hand which painted it, sheds a glory over the
painter and the picture. In the Desert, Mr Seddon had
accidentally met a young Englishman, who was near to
death, and, in order to soothe his last weeks of suffering,
took up his abode with the invalid, in the true spirit of the
' good Samaritan,' and never left him until he had closed
his eyes in peace. It was during this time of watching
beside the otherwise desolate deathbed of a stranger in the
Desert, that this beautiful picture was commenced, and
almost entirely painted. It is lovely to recognise how,
when the hour of his own need arrived for the painter—also
in the Desert—a ministration of human love was raised up
for him who had on a similar occasion so nobly acquitted
himself of the last duties towards a fellow-sufferer." *

" PYRAMIDS, *March* 27, 1854.

" MY DEAR E——,— You will be, perhaps, sur-
prised to hear that our plans are changed; but the fact is,
that Hunt discovered, two or three weeks ago, that when
Jacob left his father's house he was a middle-aged man of
forty, which has stopped him from painting a picture of
him in the wilderness, as he had intended to have done at
Sinai; so that, not being a landscape painter, he thought

* *Athenæum,* Jan. 3, 1857.

he could not spend a whole summer there. So we start in a few days for Damietta, a branch of the Nile little visited by travellers, and thence by ship to Jaffa and Jerusalem; whence we shall go, as soon as the heat is great, to Lebanon. It seems that immediately around Jerusalem the country is quite quiet, and in Lebanon the Emir of the Druses is made governor of the country; and, being a great thief, you are now perfectly safe there, if you have an introduction and make a suitable present.

"On Saturday I was driven into Cairo by a violent Khamseen wind, the first real one this year. When I got to the river, the boats would not cross; so I had to get into one, and drop down with the stream to Boulac, without any sail; and I found it worse at Cairo than at the Pyramids. Many people walked about with their heads tied up in handkerchiefs; for the dust was so thick that you could not see a hundred yards, and the heat was suffocating. At the hotel, I found Lear and Hunt done up. Our bedrooms, which are in front, and to windward, were unbearable; and we retreated into some back rooms, which had been shut close, and whose windows looked into a small court. Towards night the wind lulled to a dead calm; but the air was hotter outside than within. However, a little rain fell, and the next day was rather better. I returned here on Monday; the weather since has been lovely. The sun is now very hot; but as long as the wind is from the north there is a cool breeze. One or two days last week were very hot, the thermometer, I should guess, about 90° in the shade; but it is very endurable.

"To-day my boy's mother came to me, and asked me to write a paper to prevent her husband's beating her. In

vain I represented that it was a very delicate thing to in-
terfere in; that, in fact, the beating was a very good thing,
and would make her the better; and, finally, that I could
not write in Arabic, and that nobody in the village could
read English. She said that English would do just as well;
so, as it was no use insisting, she brought me some paper,
and I wrote—'I hereby order Abdallah Ebu Kateen not to
beat El biut esma Miriam biut l'el Zobeid, his wife, under
pain of my heavy displeasure; and if he persists, I shall
send the Howager Hunt to settle him.' (Signed) 'THOMAS
SEDDON.' The lady was delighted, and blessed me, and

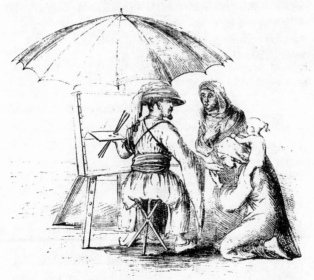

knelt down and kissed my hand; and her son and she
called me all the grand names in the world. Behold

me receiving *quasi* divine honours in my painting costume, consisting of a wide-awake hat, with my kufeeya round it as a turban, and a long white Arab shirt and shawl! This has many conveniences, which I cannot make Hunt appreciate. All above the girdle forms a huge pocket, into which anything and everything may be stuffed. My man, Hippopotamus, keeps there a select collection of snakes, scorpions, and lizards. The other day, not being able to find him, I looked about, and saw a familiar turban and pair of shoes, and close by a pair of legs, being all that remained above ground of Hippo, who was in eager exploration of a long hole not nine inches high. He had gone in recklessly in full livery, which was fortunately not covered with embroidery, merely leaving his turban, as it was too large to squeeze into the hole.

"It is very amusing just now to watch the operations which Mr Marriette is carrying on for the French Government round the Sphinx, where he is searching for an entrance. There are about one hundred children removing the sand. Some eight or ten men and bigger boys fill small round baskets with sand, and there are two gangs, one of boys and the other of girls. Some elder ones lift the baskets

on to the heads of the children, who carry them up the slope in two long processions, the head boy and girl singing, and the others all joining in chorus, and laughing and joking and shouting, while two or three majestic old Arabs stand by as overseers, with store of vociferation and blows, not serious, which, coming on their loose drapery, only just keeps them at work, and rather increases the laughter than otherwise.

"*P.S.*—Tell S—— R—— that the Pasha is very fond of pigeons, and has very beautiful ones of all kinds. His favourites have little collars of pearls and precious stones."

"Tomb at the Pyramids,
"*March* 29, 1854.

"My dearest Mother,—I am now installed in a tomb, where I have been for the last three weeks, with my trusty 'Hippopotamus.' It is a spacious, square room, with a recess opposite the door, in which a sarcophagus probably once stood. Since poor Nicholson left it, I have inherited it, as it is cooler and more comfortable than the tent. There is a smaller tomb just alongside, where the *cuisine* is carried on. In mine, one half has mats laid down, and my travelling bedstead, consisting of two iron trestles, with two boards laid across them, which has the advantage of being very springy and unbreakable, and is necessary in Syria, where it rains occasionally. My portmanteau and washing gear are on the ground by the head, with a water-bottle; while my books, drawing materials, pistol, &c., repose each in a bag under the bed—an excellent device against the sand. The other end is occupied by the canteen, and tent, and larder, which consists of a wooden peg, generally occu-

E

pied by three or four snipes and peewits; for, while painting, I keep Hunt's gun beside me, and generally kill enough snipes or plovers for my living. I confess to being a frightful pot-shot, taking any unfair advantage recklessly. The other day an Arab shot a heron, and said it was good for eating; so I tried it. It was boiled, and I found it excellent.

" It is by no means impossible that you may see my boy 'Hippopotamus' in London, as the Pasha has presented a lady hippopotamus to the Zoological Gardens. It will be sent over about May, and I believe his services will be required.

" The other day, while painting an Arab tent, the son of the Shekh came and asked me to come and take some coffee with him. I accepted his invitation, and accompanied him to the tent, which was very spacious, and made of camel's hair, in broad stripes of brown, black, and white. There was a separate tent near for the women, where the cooking was being carried on. The centre of the tent was covered with mats, leaving a space all round for the servants and the chickens, the latter having an uninterrupted run throughout, and occasionally a lamb or young buffalocalf took a deliberate walk round to look on. A carpet was spread in front between the two tent-poles, and a cushion in a case of large-patterned chintz; a mogrebby cushion of leather, with leather fringes, was placed on my right hand, and another at my back, resting against the tent-pole. Thus we sat down, having left our shoes just outside the mats. The Shekh sat opposite to me, and two men who had accompanied him squatted down in front of the mats. While a boy was despatched to order the coffee, which was made in the women's tent, the Shekh offered me a pipe; and,

while smoking it, I had time to examine the interior. It was a large, square tent, with skirts fixed perpendicularly to the ground. Over a bar, which ran from pole to pole, hung a very handsome pair of hedjazee camel bags, which seemed to contain the wardrobe. At the right-hand corner of the entrance stood a large red earthen water-jar, balanced on the left-hand side by a curiously-shaped metal vase, about eighteen inches high. On this side, also, was a pile of folded carpets and Arab blankets. During this time some dozen men and boys had dropped in; but, being of inferior degree, squatted down in a row in front of the mats, looking on and talking. The coffee was brought in in a pot on a brass brazier; and soon after a low table—or what we should call a stool, upon ball-turned legs, exactly like those of the time of Elizabeth in England—was brought in, and the luncheon was placed upon it in a basket-work tray. It consisted of eggs fried in butter, a white cream cheese, in a small earthenware basin, and dates, the space round the dishes being filled with flat cakes of bread. The Shekh led the way, by breaking off pieces of these cakes, and dipping them into the melted butter, and eating them; and then cutting the eggs in pieces, he doubled up a thin piece of cake, and took up the pieces. The cheese was then turned into the dish, and disposed of by our fingers in the same manner. We then smoked a few pipes, and finally I took my leave."

"PYRAMIDS, *April* 10, 1854.

"MY DEAR E——,—We shall not arrive at Jerusalem till the grand ceremonies of Easter are over, which I am not sorry for; for the squabbling and fighting between the

Greek and the Latin Christians may amuse the Musleim, but must be very painful for Christians to witness, and I have no wish to begin my visit to the Holy City with a dose of disgust.

"To-day, while I was painting just on the edge of the desert, several large herds of camels passed slowly browsing along on their way to Alexandria, and, as far as I can see, the sand is dotted with other herds coming up. If I were not very busy finishing before leaving, it would be a good opportunity for sketching them.

"I find that, during the week I have been in Cairo, the men from the two villages have been sent off to the railroad to work for three months. The Pasha does not think of paying them. No wonder that the Fellahs are slavish, when they are ruled by means of the stick. It is a very serious matter, as in another week the harvest will begin. The Pasha does not take the Arabs, because he dare not, and if he did, they would not work : so they are all idling about. The present Pasha is a great cur to the country. He is a bigoted old Turk, caring for nothing but his own ease and vices. To shew how he values his own servants : when Mr Murray was the consul-general, he had great trouble to induce the Pasha to attend to Stephenson's wishes about the railroad. Among other things, the Pasha wished the Arabs to drive the engines. Mr Murray objected, and said that Europeans would never trust their lives to them ; to which the Pasha replied, that, of course, he never intended that Europeans should go in the first trains, nor until they had had proper experience ; that they would fill a few trains with cawasses (policemen), and then, if any accident happened, it would not matter.

" On Saturday afternoon, as a large party was going to see Abbas's large town palace, we took the opportunity of joining them, as it is very seldom shewn. Really it was worth seeing, to learn how enormous sums can be lavished upon the most frightful ugliness. The exterior is like a huge manufactory, painted rhubarb colour, with mustard coloured lines. Inside are two or three enormous rooms and halls, floored with marble, and lined with looking-glass. The furniture is very showy, and all from France ; but the decorations of the walls and ceilings are worse than the ugliest penny theatre that ever graced the *place* of Dinan, or any English country town. The most *recherché* combinations of vile colours, as scarlet with pink, dirty yellow with bright blue, meet you everywhere. They brought us sherbet before we left, on trays with cloth of gold thrown over them; and the servants, in handing them, held long napkins, with the ends most beautifully embroidered with gold, which they spread over our knees while we drank. Abbas has a mania for building palaces—a most expensive one for the country; for at his death they will go to his family, and the new Pasha will begin new ones for himself. One of his fancies is to have a palace on an almost inaccessible rock, a thousand feet higher up than the convent at Sinai, which is being built now. Everything has to be carried up on men's backs, and a regiment of soldiers are making a road to it ; for he insisted upon having both road and palace finished at the same time."

" *Tuesday Evening.*

" DEAR E——,—I look forward with great reluctance to my move to Jerusalem. I had made up my mind to Sinai

as a place of banishment, where there would be no help for it but to work till I could leave with something worth bringing back to you; but Jerusalem is almost moving nearer home, and I feel most horribly tempted to fly back to Dinan at once. Nothing restrains me but the same sort of shame that kept many a good knight of old from cutting the Crusades, and sailing back to *la belle France* and his lady-love. So, as I must not let you cry "Shame!" I suppose I must on and wield my brush in defence of the holy city from all misrepresentation. Last night I was reading in Keble the poem for the Monday before Easter, which I remember was your favourite. Its exquisite verses have inspired me with a great desire to paint the Garden of Gethsemane by moonlight, if it be possible. Is there any place at Jerusalem that you wish to see? If you will tell me I will paint it.

"To-day has been a day of misfortune. The boy has smashed the top of my paint-box, and I sat down upon my green glass goggles, and seriously damaged them. As there are always three accidents at a time, I hope the third happened yesterday. M. Marriette's three monkeys came in, just as I was at breakfast, and sat in a ring to see me eat, and receive any small charities; when the biggest, who had put on a most hypocritical look of innocence, suddenly pounced upon my bread, and got clean off with it, in spite of mine and Hippo's efforts. It was serious, as it happened to be the only piece that I had in the cave."

"*Good-Friday Evening.*

"My days pass away here so eventlessly that I have little to tell you of. I begin to understand how the Israelites be-

came tired of quails. For several days I have had two
quails and haricots for breakfast, one quail and rice for
lunch, and two quails and rice for dinner. One can only
object to the repetition, for they are in excellent condition.
This morning a man brought fourteen, but I could not pos-
sibly bind myself down to another week's quail diet, so I
only bought five for sixpence, and declined the rest. They
net them at night with long nets, exactly as is represented
in the paintings in the tombs. The water is all drying up
now, so that I cannot get waterfowl, and I have no time to
walk the partridges up in the corn and clover. Hunt came
out yesterday to finish a sketch he had begun of the Sphinx.
He rather encourages me about my picture of the Pyramids,
which I hope will look tolerably well when finished. The
crops are beginning to be cleared off, and the soil, which
has been like the bed of a recently dried up pond in hot
weather—all cracked, like an elaborate map of the world—
is falling into dust. In another month the whole country
will be a plain of dust, dotted over with villages of
mud, and palm trees whose trunks look like baked
mud."

"PYRAMIDS OF GHIZEH,
"*April* 25, 1857.

"MY DEAR E——,— This khamseen is a terrible
infliction, but to-day there is hardly any wind. The air is
as hot as in a furnace-room. The people from India say
that they never have such oppressive heat there. On Mon-
day I persisted in working under my umbrella in the plain,
but I was obliged to give up at four o'clock ; and to-day I
feel that it would be most imprudent to attempt it. Even

the Arabs complain, and I saw to-day a camel with its head covered with wet cloths, and they said that it had had a sun-stroke. The poor sheep stood for hours with their heads under each other's bodies, to get a little shelter. I cannot conceive anything more beautiful than fine weather in Egypt. The bright sunshine, with a refreshing breeze from the north all day, is not at all oppressive, and towards evening it becomes quite cool; but when the wind is south, or south-west, the sky all round becomes murky, and gradually loses its blue, and becomes sand-coloured, and puffs of hot heavy air come at intervals, generally increasing to a storm of wind at about mid-day, subsiding towards evening, and leaving an intolerably hot heavy stillness in the night. Even the large hawks sit motionless on the sand-hills, bored to death.

"Mr Marriette shot a hyæna last night, which Hippo told me, 'Like very much eat up one horse for Howager Marriette; he no gib him horse, so he hit him gun.' The fact is, that the horse is hobbled at night, and fastened just in front of the cave where Marriette has taken up his abode, and the hyæna wanted to make a meal of him.

"Just now all the Greeks are leaving, being ordered out before Saturday. There are about two thousand in Cairo, and to many of them it is utter ruin, as their businesses are long established, and many have been born and bred here. The Government force them to pay all their debts before leaving, but will not assist them to recover any, and those who are unable to pay will probably be bastinadoed without mercy, as soon as the time expires; for the Turks are enraged against them. Substantially, the Emperor of Russia is right; sooner or later these people will have to be

governed by those who are more intelligent, for they them-selves are utterly degraded."

"CAIRO, *Friday.*

. . . . "I hope, as spring comes on, that you are all thawing in body and mind at Dinan, and that a little life is budding out of its dulness, like the flowers of the date palm here. We are now in the middle of a combined autumn and spring. The leaves are now all turning dull, and falling, and half the trees have their new beautiful bright green foliage. The palm is sending out little grace-ful plumes more feathery than its leaves—these are the flowers; and men are busy in every date-bearing tree fertil-ising the flowers with farina. They are also harvesting fast, the sheaves being carried upon camels, and upon men's heads. Their mode of thrashing is most delightfully lazy : a man is driven round in a circle over the straw, in a large easy chair, on a sledge drawn by two lazy oxen—a perfect emblem of tranquillity, and of a nature which never hurries itself."

CHAPTER VI.

JOURNEY TO PALESTINE.

WE are allowing Thomas Seddon to be his own biographer, and copious as are our extracts from his letters, we hardly think that our readers will deem them too long. Few have described so vividly the scenes and experiences through which they passed, as he has done in these frank communications to his friends of what occurred day by day, and of what he saw, while the impression was fresh in his mind; for, in addition to the keen observation of an artist, he had a thirst for general information; and, from his knowledge of the languages of the inhabitants, he was able to sympathise with and appreciate them, and was, by his work, more thrown among them than travellers usually are.

> " ESNEE, AT THE MOUTH OF THE NILE,
> "*May* 24, 1854.

"MY DEAR E——,—We have been waiting five days for a calm day to pass the bar. The wind is nearly due west, and if we could only get a start, we should be at Jaffa in twenty hours; but here we are prisoners, within a quarter of a mile of the sea, on a flat piece of sand, where there is nothing to do. I have been very unfortunate lately. A fortnight before leaving Cairo, I rather foolishly worked out

in the sun, under my umbrella, on a Khamseen day, which quite knocked me up, and I felt so unwell that I went to a doctor. He said that I was very lucky to have escaped so easily; that there was nothing wrong about me, and I need take no medicine, but rest completely for some days; so that I was obliged entirely to lose ten days. Then we conceived the unfortunate idea of coming by Damietta, which we calculated would occupy about five or six days more than the route by Alexandria, and this we thought would be fully compensated by the sketches we should be able to make, and by a saving of half the expense. We evidently started under an unhappy star. The wind was dead against us the whole way, so that we were seven days in getting to Damietta; and now seven days have passed, during which the wind has always been too high to allow of our crossing the Bongaz. But when I come to real misfortunes, and describe the miseries of our *cuisine*, I think I shall have established a strong claim to your pity! We

have taken a passage by one of the traders between Esnee and Jaffa, a ship of about fifty tons, without deck, and

carrying two lateen sails and two jibs. I believe they are very fast sailers, and go near the wind. She is now lying by the river bank, with half her cargo in a boat alongside, and half on shore, to lighten her, to enable her to pass the Bongaz. Her crew all speak Arabic, except a young man, who we were *mis*informed was a good cook, and who gets up some almost unintelligible Italian and three words of English.

"We came here from Damietta on Monday evening, just after sunset, and found nothing ready. Hunt looked horror-struck at our destiny : however, by dint of great exertion, we got a little corner, as large as a small pig-stye, covered over with a sail ; and, having spread our blankets, I must confess that I slept admirably, in spite of itinerant cockroaches. As it was evident that we could not get away the next day, I had the tent pitched on shore, and had to get everything ready for breakfast. This was four hours' hard work ; but, at any rate, afterwards we were quiet and comfortable. I called on M. D'Arnoud, a French engineer, who has been twelve or fourteen years in the Egyptian service, and has travelled to within four degrees of the equator in the centre of Africa. He is extremely kind and obliging, and a very clever and scientific fellow. He has lent us a nice little boat, so that we are our own masters, and can go wherever we choose. He is now en- gaged in building strong fortifications at the mouth of the river, after which he hopes to remove the bar at the mouth, or improve its passage. After I had stayed some time, he returned with me to call upon Hunt. When D'Arnoud left, he told me that he had never had such a day in his life. The cook had been attempting to put our luggage in order, and asked him to come to superintend, and put to him

various questions in Arabic, which he answered in English. If told not to untie a package, he said, 'Yes, very good,' and instantly untied it. Then Hunt shouted, 'Don't you hear? I told you not to untie it;' and the fellow grinned like an ape, and said again, 'Yes, very good.' Hunt told me I should see what they would give us for dinner, and certainly I was startled when it appeared. First they brought the plates, the soup-tureen, and the knives and forks, and set them in a heap before us: then two sauce-pans, into which they had stuffed soup, fowl, and rice all together, with the vegetables in the other. I saw that we were to dish up ourselves, as they were in a state of helpless ignorance as to the use of so many plates and dishes. So I fished up a ghastly fowl, in the same attitude in which it had breathed its last, with a melancholy expression in its eye, and as gaunt as an elderly Scotch spinster. I enclose you a sketch of it from nature.

"However, I must tell you something about our voyage down the Nile, which I may begin by observing that it is extremely like the Thames; and, excepting where you see palms and mud villages, you would imagine you were at Battersea or Putney: for the other Egyptian trees are very like English ones, and the grassy, weedy banks are covered with exactly the same sort of plants.

"We left the hotel at Cairo on Wednesday evening the 10th, about seven o'clock, and on arriving at the wharf, found that the police-officer, whose duty it is to examine

parties before departure, had left; so that we were obliged to remain until the morning, and we were prevented from spending the evening with Mr Bruce, who had left two hours previously to go boar-shooting. The quays at Boulac, crowded with the Nile boats, with their forest of tall sloping yards, offer a far greater variety of character and costume than the streets of Cairo, where the greater number of passers-by are more or less broken in to the habits of town-life. Here you see boats, just arrived from the upper country, with the native merchants and their goods. On the shore the goods which have just been landed from the boats are piled up in separate heaps, with their owners seated upon them, and sleeping on their bales to guard them. About a dozen Nubian girls, in their scanty costume, were cooking, or preparing the evening meal for their owners; and several little children were seated as happy and thoughtless as monkeys, within an enclosure of cotton bales. Alongside, our neighbours were some Syrian merchants from Bethlehem, with their fairer-bearded faces and aquiline noses. Their cargo was beads, on which Muslim, Greek, or Catholic, indifferently, may count their prayers. Every colour of the rainbow was ready to tickle the fancy of the devotee; but, as we were pilgrims to Bethlehem, we resisted the temptation, although pressed upon us with most winning smiles. The Nile boatmen formed quite a class apart, and Turks from more distant parts wore turbans of far more imposing dimensions than those which are usually seen in the town.

"We had a strong wind against us, and only arrived at Bennah on the third day. It is forty miles by river, and twelve by land. On approaching, we passed some of the curious pigeon-house villages of Egypt, looking like a collection of

huge mud sugar-loaves. There are some villages consisting
of two or three thousand of these—the men living in the
base. I believe they are very profitable, some of them

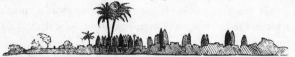

yielding a revenue of three or four thousand dollars. I
have sketched for you one, which is more picturesque than
those which consist of nothing but pigeon-houses, and which
will explain their character. Bennah, just now, is in a
wonderful state of confusion and bustle; for they are building
the railway bridge, and English navvies, in wide-awakes and
flannel jackets, are working amid thousands of *fellahin;*
and the clank of hammers and puffing of steam-engines
contend with some success against the screaming of the
Arabs. The bridge is a triumph of intensely ugly science.

It is a square iron tube, supported upon pairs of wrought-
iron hollow tubes, like opera-glasses. We staid a few hours
at Semennood, which is the most picturesque town we
saw during the journey, as it stands on high heaps of rub-
bish, the remains of an ancient city. The bazaars run along
the river bank, so that, looking through the shops, there
was a beautiful view of the water through their back win-

dows. We were told that we should see much better ones
at Damietta, so that we only remained two or three hours, and,
unfortunately, met with nothing afterwards at all like them.

" It was very curious to see the buffaloes swim across the
river in the mornings and evenings, going to and returning
from pasture. The herdsman made his clothes up into a
bundle, and tied it upon his head, and swam after them,
occasionally hanging on by a tail, while little naked urchins
sat perched on the backs of the larger beasts. During the
heat of the day we passed whole herds lying in the water,
with only their heads or noses projecting, and far too lazy
to move for our towing-rope, which scraped over them.
They are evidently true philosophers. One thing that I was
not prepared for in Egypt was, to find it so cloudy. At Cairo
there were passing clouds every day; but during the ten
days after our leaving Damietta, certainly five were dull and
cloudy, and we had two or three showers of rain. I believe that
up the Delta the climate is very different from that of Cairo.

" I send you a sketch of our boat, which is a good speci-
men of the Nile boats. It is a *sandal*—the smallest size
—with a *reis*, or captain, a very good-looking Abyssinian,
and four men, who row capitally, with a boy to steer—
varying in hue from coffee colour to lamp-black. The boat
carries two triangular sails, and just behind the mast is a
cooking-place, and in the stern are two cabins, with a
dressing-room twenty inches wide between. The first cabin
is about six feet wide, by eight feet long, with a seat on each
side. The back cabin, about six feet long, has a flooring
about three feet from the ground, which is covered with a
large mattress and pillows to sleep on, while boxes can be
stowed away underneath. It is fitted up very nicely for

English travellers going up the Nile, and having just re-
turned, is very clean and comfortable.

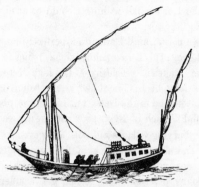

"Damietta is a large town, lying very picturesquely upon
a hill, sloping down to the river-side, where many of the
merchants' houses have small court-yards in front, fitted up
with benches, and with roofs of trellis-work covered with
vines, and with stone steps leading down to the river, much
like what I imagine the houses in Venice to have. We
found the vice-consul, a Syrian, exceedingly attentive. He
went with us about everywhere, apologising for leaving us
occasionally, and taking us to see his new boat and his new
house; and finding that I was fond of horses, his whole
stud, colts and all, were trotted out for our inspection.
We dined with him, and shewed him how to mix mustard
à l'Anglaise. After dinner we began to smoke. The first
pipes were six feet long, with amber mouth-pieces; and
every ten minutes, a set with longer stems and richer mouth-
pieces was introduced, till, after examining a whole arsenal
of guns and pistols, and exterminating the Russians several

F

times, the pipes had become eighteen feet long, with amber tops as large as hen's eggs, wreathed in diamonds; and as nothing short of a small palm-tree could come next, we took our leave.

" The country around Damietta is perfectly flat, and a great deal of it consists of rice fields, which, being kept covered with water, makes it unhealthy. The lake Menzaleh, about forty miles long, begins about half a mile from the town. It was the finest land in the Delta, until in the war between the English and French in Egypt, we cut the dykes and let in the water, burying villages and all. However, as it is, there are such enormous quantities of fish and waterfowl, that it yields nearly as much revenue as before. There are a great many pelicans there, which get wonderfully tame when caught. M. Marriette had one which formed an attachment for his cat. It used to open its beak and take pussy into its pouch, where she would go to sleep quite contentedly. One day, Madam Pelican snapped up the monkey, who was frightened out of his wits, and screamed and shrieked till the pelican was tired and let him out.

" While taking a walk one afternoon near the lake, we went through a most lovely wood, just like an English one, with long grass and flowers, and orange and pomegranate-trees, covered with their crimson blossoms, among the underwood. But the oddest thing we saw was a procession through the streets, conveying the property and dowry of a bride to her husband's house. First came women, carrying jewels and a set of coffee things, trays, jugs, pots, saucepans, &c.—no one carrying more than one thing, in order to make a great show. Then, men and boys, carrying two or three ottomans, cushion by cushion; a huge box, painted bright green, large

enough to hold the young couple, upon a man's back, followed by several small boxes, carpets, rugs, and mats; and the procession finished with blankets and feather-beds."

" JERUSALEM, ——

"MY DEAR E——,—The first part of this letter has been written by scraps, from time to time, during the voyage, and at Jaffa. Two days after I began we were able to get out, and, though everything was excessively rough, we got to Jaffa in four days. The wind was very light, and we were becalmed two or three times. The day before we arrived we came in sight of Jaffa at five in the morning, and, from the way in which they steered, I saw that we were being drifted in-shore ; and I told the captain that, if he did not keep out, we should be ashore, which very soon happened. They got out the oars, and tried to pull out ; but from its being Ramazan, when they fast from sunrise to sunset, they could not and would not pull : so, as a last resource, the captain ran her into a little bay which was full of rocks, and anchored with rocks on each side, certainly not ten yards off. Fortunately the wind fell, and here we had the pleasure of seeing Jaffa all day long. In the evening the land breeze sprang up, and we got in before daybreak on Tuesday, the 30th of May ; and, as there is no post to Europe till the 10th of June, I waited till I got to Jerusalem before going on to inflict another sheet on you; not that I can reasonably expect you ever to get to the end of such an unmerciful epistle ; but, as I have only consulted my own pleasure in writing, pray consult your own convenience in reading. We arrived here on Saturday the 3d and, after having seen the city and the country round, I am

going to live in my tent on the hill south of Mount Zion,
looking up the Valley of Jehoshaphat. Hunt remains in
town, and, as I have left all my books at Jaffa, and engaged
a cook who only speaks Arabic, I shall have no distractions.
There are three large pictures which I should like to do,
but I shall only have time, I fear, for one, and a small sketch
or two. Thank God, I never felt better in my life, and
hope to be able to work well. I have not yet found the
climate hot; the sun is very powerful, it is true, but there
is always a cool breeze; indeed, neither here nor in Egypt
is the heat half so oppressive as on a really hot close day
in England."

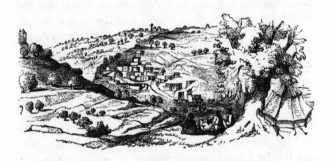

" View looking up the Valley of Jehoshaphat, through which the Kedron
flows (in winter). In front is the Mount of Olives, with the village of
Siloam creeping round the foot of the nearer mount, which is the Mount
of Offence, where Solomon erected altars for his idolatrous wives. On the
left is Mount Moriah (in shadow), with the commencement of the Temple
wall—in the lower part still as Solomon built it with enormous stones. In
front of it is the lower part of Mount Zion, rising out of the valley. The
broad part of the valley, just under the olive-tree, is the site of Solomon's
gardens, and now all gardens or terraces down to the slopes, and very
beautiful now, for the pomegranate-trees are in full flower. The Arabs are
resting in a row, after pitching my tent."

"JERUSALEM, *June* 10, 1854.

"MY DEAR E——,—Though I was very sorry to give up my plan of going to Sinai, I do not regret it now, and only wish that we had left Egypt two months earlier ; for, independently of the undying interest that must ever belong to Jerusalem, the country is exceedingly beautiful, and by no means the barren place I expected. The whole plain, from Jaffa to the hills, was covered with corn ; and though the mountains are wild, it is only for want of cultivation. Many are planted with olive-trees, and, near the Arab villages, corn, vines, figs, and pomegranates grow on their very tops, shewing how fertile they would be if again inhabited by an industrious people like the Jews of old. Quite enough remains to shew that it was a 'land flowing with milk and honey,' and 'the garden of the whole earth.' The hills are of limestone rock, lying in flat strata one above the other, forming small terraces all the way up ; and if, with a little care, these were terraced regularly, so that the soil did not wash down, as it does now—as water is plentiful by means of irrigation—the whole hill-side would be covered luxuriantly.

" I suppose that six months spent on a plain of flat mud like Egypt, must be a capital preparation for seeing and enjoying mountain scenery. Besides the beauty of this land, one cannot help feeling that one is treading upon holy ground ; and it is impossible to tread the same soil which our Lord trod, and wander over His favourite walks with the apostles, and follow the very road that He went from Gethsemane to the Cross, without seriously feeling that it is a solemn reality, and no dream.

" I am told that, a month ago, the Mount of Olives was

covered with beautiful flowers; now they are all over, and, as most of the corn is cut, it is rather bare. It is dotted over with scattered olive-trees, which, in our Saviour's time, were probably thick groves, giving a good shelter from the heat of the sun. Its present look is peculiar; the rock is a light-gray limestone, shewing itself in narrow ledges all up the sides; the soil is whitish, and the grass, now burned to a yellowish colour on the ledges in narrow strips, forms altogether a most delicate and beautiful colour, on which the gray green olives stand out in dark relief. The evening sun makes it at first golden-hued, and afterwards literally, as Tennyson writes, 'the purple brows of Olivet.'

" The first place we came to in Palestine is a complete contrast to everything in Egypt. Jaffa stands beautifully upon a large rocky mound, in the centre of a large bay. There is no port, but small ships lie inside a reef of rocks, which jut out in a curve from the point on which the town stands. It is a very flourishing town, well built of hewn stone, with an air of comfort and wealth which astonishes me, coming from Egypt, and it stands within its old walls, which are doubled on the land side. The streets are so steep that horses and mules cannot be used inside the town, and, from being built thus upon a steep rock, at every turn and opening you get glimpses of the sea, often through some archway as old as the crusaders in appearance. The people are much finer and more independent than the poor oppressed Egyptians, and are very well off.

" We went to see the house of the tanner, on the roof of which it is said Peter was praying when he saw the vision; and, though the house is probably more modern, there is every reason to believe that it is really the same spot, as it

is quite at the end of the town, at the outside of what must have been old Joppa; and in the court is a well of water and trough, such as those used by tanners, with a plentiful supply of water for the trade, and a square yard very fitted for it. You enter a room, to the left of which is a doorway leading into a square-vaulted chamber, with a window looking over the sea. In the first chamber there is a window on the left, shaded by a fig-tree, through the leaves of which you see the sea. The door opposite the entrance leads into a court, in which is a water-wheel, with a large trough by the side, and a fig-tree overshadowing it in front. To the right is a thick wall, with old embrasures for cannon, and to the left a beautiful view along the shore, with a few flat-topped houses, and the town wall, of great antiquity (probably Roman), immediately beyond. The view, looking along the line of cliffs, is the same that Peter gazed on ; if I can spare a fortnight on my return I will paint it, as I think that it would be generally interesting. The country outside the town is a most luxuriant garden, a mass of orange and lemon-trees, pomegranates covered with their

crimson blossoms, and dark green mulberry and fig-trees, with white and gray country-houses, lying buried in the foliage ; and near them are water-wheels, generally shadowed by large sycamore-trees, with a few palms rising here and there out of the bright green masses below. The walks among the gardens are little lanes bordered by broad and

large cactus hedges, on raised banks, tangled with long grass and flowers, with bright red poppies and purple thistles, and many other tall umbelliferous plants, as in England. Here and there were huge fig-sycamores, with vines fantastically climbing to their topmost branches, and in other places hanging down in long wreaths swinging in the wind, till their ends trailed upon the ground. When we looked back from the top of any height, we saw the white town of Jaffa on a hill, crowning this glorious garden of richly-varied green, backed by the blue sea, which ended in a deep bay on the right, bedded in the bosom of the golden sand.

"We called on the consul, M. Assaed Kayat, who is a Syrian, but has been for some time in England, and has learned to appreciate us; so that, to our astonishment, we found a piano and an English governess in the house. The consul is very polite, and offers, if we stop, to introduce us to native families who would sit for painting. He is doing a great deal of good, encouraging the growth of silk, and he is now introducing cotton, which is likely to answer well. He took us to see his silk-worm establishment and farm. The ground was waste five years ago, but now he has a flourishing garden, watered by a Sakeeyah, a fine crop of wheat of two hundred and fifty acres, a plantation of palms from Egypt, and another of cotton. Speaking of the present war, he says that it is of the utmost importance to insure the equal rights of Christians, and he fears the allies will trust too much to Turkish promises. He thinks that the Sultan should be induced to proclaim liberty of conscience, and then, he believes, many Moslems would turn to Christianity; or that, at any rate, they would avail themselves of instruction, which would soon bring about the same thing. As

long as they remain Moslems improvement is impossible. The soil of Syria is beautiful, and, with a settled government, would form a fine field for emigration. I afterwards saw Mr Kruse, the missionary, who complains of being left with very little means ; he is about to open a girls' school on his own responsibility.

" We left Jaffa at half-past three o'clock, on the 2d of June, with seven mules, carrying our boxes, tent, canteen, &c., Hunt and myself being upon horseback, and three muleteers on donkeys—one being the very image of Sancho Panza. Our steeds, knowing that we had neither whip nor spur, crawled out of the town, and we thought that they had no pace in them ; but when I pulled a prickly stick out of the hedge, before they had been touched, they shewed signs of exceeding spirit, and broke out incontinently into a most respectable gallop. Travelling with baggage mules is slow work—two miles and three-quarters an hour being about the average. Our afternoon's ride, after three miles passing through gardens hedged with cactus, lay over undulating downs, half covered with corn and half pasture, with scattered groves of very old olives, under which cattle were feeding. The villages are clean and substantial, built on slight eminences, surrounded by gardens of cucumbers, Indian corn, &c. It was a pretty sight to see the whole population of the villages out harvesting on the hill-sides. The men cut the corn and handed it to the women and girls, who bound it into large sheaves (not such poetical little sheaves as painters put daintily on a delicate lady like Ruth), and then carried them on their heads into large heaps, ready for the camels to carry to the village ; in the rear the goats and sheep were eating up the leavings,

guarded by the children. These busy scenes had the lofty hills of Judah, glowing in the evening sun, for a background, with their tops half shrouded in clouds. On the pastures we passed through large herds of milch camels and their young, some of fully twelve thousand or more, so that the country must be very rich.

"We slept that night at the Latin convent at Ramla, which was most beautifully clean and comfortable, and the padres, as elsewhere, extremely kind and attentive. The next day, June 3, we started at six o'clock, with a pleasant breeze, and clouds enough to break the heat of the sun. In the plain between Ramla and the hills, the people were busy harvesting; the country seemed covered with corn. The costume of the women was good, a white-fringed cloth doubled and laid on the head, so that the fringes hung half-way down the back, or else wound round the head as a sort of turban, leaving the face uncovered. A few wore short veils, with three or four rows of coin along the bottom; their gowns were of coarse blue linen, girt round the waist, and with long sleeves. About nine we entered the passes, where the road winds between and over the hills, which are of limestone, generally lying in strata, so that many hills look as if terraced, and planted with olives. We then began the toilsome ascent, and we did not emerge from these passes until we came in sight of Jerusalem, at five o'clock. The way lay along the bottom of the valleys, chiefly in the beds of what are torrents in winter; the term road or path is quite inapplicable, for you have to climb and slip among a mass of loose rocks and stones. One valley, after Aboo Goosh, about five or six miles from Jerusalem, is as steep as the stairs of a house, formed of rough

steps of bare rock, on which are as many loose jagged stones as can lie upon them. Riding here was impossible; still the sides of these hills are planted with olives, and, near the villages, with figs and vines, which grow very well; the bunches will be enormous, for the flower bunches are four-teen to sixteen inches long. We had been expecting for some time to come in sight of Jerusalem, when all at once, from the top of a hill, it came in view. I do not know how or why—for I hate romance, and always have thought that travellers put themselves into raptures when they came to Jerusalem—but I never was so affected in my life at the sight of any place, and could hardly help bursting into tears. It brought the life and death of Jesus Christ so vividly and really before me, that it almost seemed to destroy the eighteen hundred years which dim its force so much, and make it appear as a story of bygone days; for in a few minutes I should be within the very walls where He endured so much suffering and agony for me : I felt that I stood on holy ground. It could not have been the aspect of the place, for, encased in its Saracenic walls, it reminded me of Avignon or Conway, and was quite different from what I had anticipated. From the west you see little but the embattled walls of a mediæval fortress, on a very slight elevation ; to the right the ground dips, but on the left it is level to the walls. Behind the city rose the Mount of Olives, with the grand range of the mountains of Moab, be-yond the Dead Sea, half veiled by the mist, now rosy from the light of the setting sun. We went to the Casa Nova, a building intended for pilgrims, where the good monks made us very comfortable ; and everything was very clean, though simple, as becomes a conventual building. They sent

for meat for us Protestants, as it was Friday, and the padre seemed in a fever because we did not eat it all.

" On Sunday it was an interesting sight for us to see the bishop and three clergymen at church, and to hear service performed with music and chanting. Seven converted Jews were confirmed, and the communion administered to more than one hundred people—English, Arabs, and Germans; and the blessing was pronounced in each language, as the case required. In the afternoon we walked up to the top of the Mount of Olives, whence you overlook the whole city, and, also to the east, the Dead Sea, which is really only fifteen miles off, and which looks quite close. This is one of the most impressive views in the world, and if I have time I will certainly paint it, but I fear that I shall not be able. On the top of the Mount of Olives are gardens, and corn-fields stretch down its sides, but all beyond seems perfectly barren rock and mountains. The Dead Sea seemed motion-less, and of a blue so deep, that no water that I have seen can compare with it. The range of mountains beyond is forty or fifty miles off, and a thin veil of mist seemed spread between us and them over the sea, through which they appeared aerial and unreal; and, as the sun sinks, the pro-jections become rose-coloured, and the chasms a deep violet, yet still misty. When the sun left them, the hazy air above them became a singular green colour, and the sky over rosy red, gradually melting into the blue.

" After visiting every part of the city and surrounding country, to determine what I would do, I have encamped upon the hill to the south, looking up the Valley of Jeho-shaphat; I have sketched the view which I see from the opening of my tent. I am painting from a hundred yards

higher up, where I see more of the valley, with the Tombs of the Kings and Gethsemane. I have begun my picture two inches larger each way than that of Dinan, and also a smaller view of Mount Zion. I get up before five, breakfast, and begin soon after six. I come in at twelve, and dine, and sleep for an hour; and then, about two, paint on my large picture until sunset. Hunt is composing a figure picture, and remains in town, and my servants and boys know nothing but Arabic, so that I have not anything to call off my attention. The English residents are very nice people, and very kind, but I have declined accepting any invitations, except in the evening; and, as the gates are closed at sunset, it is rather an affair to go to an hotel; so I shall probably not see many. There are one or two clergymen whom I should very much like to become intimate with, as they are very clever and gentlemanly. The climate here is delicious; the sun is hot, but there is every afternoon a most delightful breeze, and in the shade it is as cool as in England. . . .—Believe me, sincerely yours,

"THOMAS SEDDON."

CHAPTER VII.

LETTERS FROM JERUSALEM.

" Tent at Aceldama, *June* 25, 1854.

" My dear E——, To-day I have been
going on with a water-colour drawing of the mountains of
Moab, beyond the Dead Sea, looking down the Valley of
Hinnom. I have taken them half an hour before sunset,
when they are bathed in a mist of rosy light, while the
valley in front is in shadow. It never does to be too confi-
dent, but, if it is finished as it is begun, it will be the best
water-colour landscape that I have done. I began that,
and another, of Joab's well, and the great threshing-floor in
front, with the oxen treading the corn, as water-colour is not
so laborious as oil. I think you would enjoy this country;
there is more society than at Dinan, and some very nice
people; pianos also are no rarities. The walks and rides in
the neighbourhood are delightful. During the summer and
autumn people take up their abode in tents, about a mile
and a half from the town, where there is a little encamp-
ment of Europeans, who fly away home before winter, like
a colony of French swallows.

" Most of the English are more or less occupied here in the
missions to the Jews, and they seem to be doing a great deal

of good. They have boys' and girls' schools on a large scale, and an admirably arranged hospital, making up about thirty beds. There are not many converts yet, though there are some; but the people seem to feel that their intentions are friendly, and the children all read both the Old and New Testaments. The elder men and rabbis shew no disinclination to listen and discuss matters; many are wavering, and a great change seems to be anticipated shortly. There are an immense number of Jews who come here to die in Zion, without any means of supporting themselves, and they find it impossible to get work.

" One great peculiarity in the native Jews is, their being so totally unlike the western Jews; they are straight-nosed, and generally very fair—the men with transparent pink complexions—and they do not seem to be so money-loving. They say that the worst specimens of their race are in England and France. A great many of them here are very learned men. The oldest and best families came from Spain at the time of Ferdinand and Isabella. They are rather superstitious, and do not like being alone in a house at night. Dr M'Gowan wanted a man to sleep at his house during his absence, but the man did not like it, and said, 'You know, doctor, that there are monsters; I saw one at the Lake of Tiberias. I was servant to a gentleman, and we encampèd near the lake, and there are there horrible monsters, bigger than a large dog, and they come near the tent at night, and laugh horribly: and if you are alone, you cannot help laughing also; and if you do, you are lost, for they laugh again, and you are drawn after them, laughing, into dreadful places, and you are never heard of any more. I saw one of them myself. I was obliged to go to the town,

and was hurrying back, when I heard an unearthly laugh, and, on the top of a small hill, I saw a gentleman standing quite still, looking at it. At last, I saw him begin to laugh, and move a pace or two forward; so I saw there was no time to be lost, and took up a large stone and threw it at him. It hit him on the head and knocked him down, and so the spell was broken.' History does not say that the gentleman knocked him down in return for his zeal. The grain of truth in this is the laughing hyæna, which is common enough, but the rest is all imaginary. If, however, you intend to write a continuation of Mrs Crowe's modern ghost-book, burke the explanation, for the story is an authentic one.

"I did a good work on Friday. Having called upon the Rev. Mr Nicolayson in the morning, I found that the church was going to be disfigured by a most hideous mass of wood-work, to hold a bell, and, as my opinion was asked about it, I frankly said that it was atrocious, and then had to stay the rest of the day and design one for it. So I proposed a stone bell-turret, to be erected over the entrance to the churchyard. I think the day was well spent in saving Jerusalem from desecration.

"Hunt has taken up his abode in the house of a missionary who has gone northwards for some months, and who wanted somebody to take care of his house, which is furnished ; and he has left all his books out, with everything which could be useful ; so I shall go and sleep there occasionally when I want to write, for it is not very convenient to do so on the floor of a tent, though I am tolerably well accustomed to it now.

"*June* 30.—Really, the perfect monotony of my daily life

furnishes no materials at all for letter-writing. I never see a European, except on Sundays, unless Hunt or some one looks in, perhaps, for five minutes during their morning or evening walk or ride, to shake hands, and tell me that the report they gave me last week of a great defeat of the Russians is completely false. I get up before sunrise, breakfast, and paint till eleven; then read, *darn*, dine, or sleep till two; then paint till six; then I have to return, put up my things, and go out for a walk, and just as I go out every one else is obliged to go in, for the gun fires at sunset—seven o'clock—and the gates are shut a quarter of an hour afterwards. I have been obliged to dock my working hours down to this, for I began working from half-past six to twelve, and from two to seven; but I found myself knocked up every few days, for the mid-day is so scorchingly hot, and one cannot bear so much here as in England, but the evenings are as cool, or cooler than at home.

"I was with Hunt a few days ago, while he was moving into his new house. He had told a man at the Casa Nova, who pretends to understand English, to get him a hammer; so he went, and came back with another man, and when Hunt asked for the hammer, pointed to the fellow, saying, 'There he is,' *hummel* being the Arabic for a porter.

"The other day I was dining with Bishop Gobat; and observing how often falsehood looks like truth, and that Moslems seemed to have more resignation than Christians, he said that it led to lazy carelessness when danger was at a distance, but that he had often been with them in real danger, and then their resignation and calmness vanish, and they are so confused that they do not know what to do. Once in the Red Sea, going from Jeddar to Cosseir, they

were not quick enough in turning the sail for a gust of
wind, and the ship very nearly went over; but the mast
fortunately snapped. When the danger was most immi-
nent they left off calling upon God, and began calling *Yah
Muhammed, Yah Muhammed,* most piteously. When it
was over there was not an axe or anything to cut the
wreck loose, and there they lay until a ship passing towed
them to land; and there they had to go five miles before
they found an Arab village where they could borrow a
miserable axe to trim their broken mast, which they spliced
with ropes, and sailed thus for a fortnight.

"It is singular how completely all traces of the spots
where the chief events of Jesus' life took place are lost. It
seems as if it were a providential rebuke to any feelings of
superstitious reverence. I think that evidently the sites
assigned to Calvary and the Holy Sepulchre are false, for
He suffered without the gate, and we know that the Jews
never buried within the walls; whereas these must always
have been in the midst of the town. The Garden of Geth-
semane was probably about or near where it is now thought
to have been, for it is just at the foot of the roads up to the
Mount of Olives and to Bethany, which is just on the
eastern slope of Olivet, and that was the road that Jesus
took to come into the city the last three or four days of His
life. At present it is a small square garden, with white
walls, with two or three old olive-trees in it, but not much
older than the other surrounding ones; it is neatly laid out
in flower-beds, which an old monk goes to water every
morning and evening. The supposed burial-place of the
Virgin and Joseph is close by; it is an immense cave slop-
ing down into the ground—it is now vaulted, and a flight
of about a hundred steps leads to the bottom, where there

are altars, over and in front of which hang hundreds, nay, almost thousands of silver and gilt lamps, as thickly as they can be placed, right up to the mouth of the cave. I must try and see it upon a festival; when they are all lighted, it must be a perfect blaze of light. But really one does not wonder that the Turks, seeing the mummeries of the Greek, Latin, and Armenian Christians, and their bitter hatred of each other, fighting, and often killing each other in the very Church of the Holy Sepulchre, despise the Christians. However, they have already learned to make a difference between *Nosranee* and *Engleez*. Three or four years ago, after some disgraceful scenes in Easter-week, the old Pasha sent to the Greek Patriarch the next year, and said, that if there were any disturbance he would hang five of them, and that year all passed off quietly. The next year another Pasha invited the three Patriarchs to dine with him, and after dinner took them into the court before the Holy Sepulchre, and read them a lecture on Christian charity.

"*July* 5.—The weather lately has been cloudless, but this morning beautiful white clouds are chasing one another from the west, and their shadows scudding over the rounded hills will, I hope, give me a great additional beauty for my small picture of Mount Zion. Thank God, I am painting successfully, and am in wonderful health through living in the open country. Mr Crawford has just been here. I said to him, 'Well, we have had no great heat yet.' He laughed, and said, 'You should hear how they complain in the town, and if I spend a day there I feel quite lazy and tired.' I shall come to you soon for news of the war, for we have none here, and nobody seems to know that the world is in a commotion.—Yours, most sincerely,

"THOMAS SEDDON."

" ACELDAMA, *July* 2, 1854.

" MY DEAREST M——,—I received your most welcome
letter yesterday. You are all so kind in writing to me, with
so little answering in return. Indeed, if you knew the diffi-
culty of writing, you would not wonder. The whole avail-
able part of the day I spend in working; then I must take
a short walk after sunset, so that it is nine o'clock before I
can begin to read or write, and then I am quite fagged; but
now I have a quiet hour before going to church. My ser-
vant goes early to Arabic service, and I wait till his return.
The sky is pure blue, and I am sitting on the roots of an
ancient olive, under the shade of which my tent is pitched.
It is a noble tree, fully seven or eight feet in diameter, and
the flat spreading roots give every variety of elbow and
lounging-chair; but I am quite hardened now, and sleep
soundly on rough stony ground, with a stone for a pillow.
It is a beautiful climate; the heat in the shade is about 75°
at mid-day; but the pleasant breeze which blows continu-
ally makes it feel less hot than the same heat in England; and
the mornings and evenings are quite cool. The sun is scorch-
ingly hot for two or three hours, but it is the habit to dine
and sleep then. I get up at five, or soon after—breakfast
—paint from soon after six till ten or eleven—come in, sleep
under my tree, and dine and read for half-an-hour, till two
—and then paint as long as I can after. All the gentlemen
to whom Mr Isaacs wrote are extremely kind and attentive.
They say that they never saw artists take the pains that
Hunt and I take to be correct. I, however, see very little
of any one, except on Sunday, for I am alone the whole
week. Mr Crawford, or Mr Nicolayson, or Dr M'Gowan,
ride round to shake hands occasionally in the morning and

evening; and I see Hunt sometimes, but he is busily en-
gaged on a picture in town, in the house of a missionary
who has gone to Tiberias for the summer, and whose house
he is taking care of. One day I felt over-fatigued, and slept
and remained the day there, but I sighed for the fresh air
under my shady tree, and have not been there since. Mr
Crawford came, a morning or two ago, as I was at breakfast,
seated on the ground, and told me that I looked just like
Abraham.

" The mission at Jerusalem seems to be producing fruits,
though the number of converts is not great. There is a good
feeling towards them among the Jews, and a willingness to
listen. The ground seems ploughed, and before long I do
not .doubt that a movement will take place—at any rate,
there is a large Protestant congregation of Europeans, and
apparently a very attentive one—almost every one stays for
the communion. Dr M'Gowan took me over the hospital,
which is a most delightfully cool and airy place, making up
thirty beds. There was a learned rabbi there—a fair, ruddy-
faced, sandy-bearded man, author of two commentaries on
Job; a little bright-eyed Nubian boy; and the women were
seated cross-legged on the top of their beds; everything was
beautifully clean, but very unlike an English hospital.

" The Jews of Jerusalem are fair, especially the women,
with straight noses generally, and none of the hawk-like
look of English Jews; they say we see the worst speci-
mens of the nation. It appears to me that people make a
great mistake, in their anxiety to apply prophecy, in saying
that Judea is struck with barrenness; it has become barren
from want of inhabitants, and from great part of it having
fallen into the hands of the Bedowee : but the soil seems

as fertile as ever wherever they take the trouble of turning
up the ground, and sowing or planting wheat; and olive
and other trees grow even to the hill-tops round Jeru-
salem. The hills are a light-gray limestone, lying in strata,
so that the hill-sides form a succession of terraces naturally.
In the old Jewish time the edges of these were carefully
walled with the loose stones, to prevent the soil being
washed down by the winter rains, and the hills were covered
with trees and corn. At present the colour varies singu-
larly. Whenever the light shines directly on them, the hills
look white, with lines of yellow running along them from
the dry parched herbage; but when the sun is high, so that
the sides of the rocky ledges are in shadow, the hill is of a
glorious purple, mixed with the golden and brown tints of
the herbage. The white rock is also very susceptible of
colour, from the rays of the morning or evening sun, and the
little earth that is visible being reddish. The Mount of
Olives every evening is of a wonderfully beautiful, rather
red purple. The slopes of the Mount of Olives opposite
the Temple, and the side of Mount Zion, are covered with
the flat stone tablets of the modern Jewish graves; at a
little distance it seems as if the whole hill-side were covered
with a flock of sheep. My tent is pitched in the midst of
Aceldama. I am surrounded by the older sepulchres of the
ancient Jews—large chambers hewn out of the solid rock,
in the face of the perpendicular sides of the Valley of Hin-
nom. Often several chambers open out from the entrance,
one with recesses cut in the rock for the bodies, the lower
ones generally going into the rock deeply, so that the body
was put in feet foremost, but the upper ledges a recess
lengthways. If I were remaining, I should live in one of

them close to my tent, making the long recess on one side
my bedstead, and on the other two sides my sideboard and
bookcase. They were almost all inhabited by hermits during
the earlier Christian ages, who spent their leisure time in
making windows and niches for the crucifix, &c., and in ar-
ranging divers conveniences. In one, which my man occu-
pies as a kitchen, I have a plentiful supply of water in the
back chamber, which is a great convenience.

"Just under where I am the harvesting operations are
going on all day long, as it is their principal threshing-floor;
all the wheat is collected there, being brought either on
men's heads, or on donkeys. Each proprietor places his
own in a heap by itself, and men are appointed by the
village to guard it by day and night. The threshing is still
more rude than in Egypt, and a very slow process. They
drive cattle and donkeys over it in a circle, which reduces
it into powder, and then they throw it up into the air in the
morning and afternoon breeze, to blow away the chaff.
Before daybreak the vocal performances of the donkeys and
the bleating shew that a move is going to take place, and
soon small clouds of black goats and sheep issue from the
little rocky village of Siloam, and spread over the moun-
tain side, amid the shouts of the Arabs driving or leading
them to pasture. In about half-an-hour troops of donkeys
come galloping madly down the steep road, with men run-
ning and urging them on to Joab's well, and soon return,
now slowly climbing up to Jerusalem with water for the
inhabitants to drink. Poor donkeys! they and their drivers
have a hard life; they gallop madly down hill, and creep up
with their heavy water-skins till sunset. The spring of
Siloam is intermittent, so the time when the water flows

varies ; but when it does, the screams of the women and shouts of the men, all quarrelling, and trying each to get as much as he or she can for her own garden, quite drowns the plashing of the little cascades of water, leaping from terrace to terrace, and running along the little channels, and so distributing itself all over. When the head-man thinks that one division has had a sufficient share, he has that channel stopped, and then every man, woman, and child belonging to these gardens bursts into a scream of indignant remonstrance at the injustice of giving them so little ; no one ever allows that they have had a fair share themselves. In the middle of the day all the flocks are driven in to water, and then they remain on the mountain sides till after the sun goes down. You see them returning in long strings, generally with a shepherd in front and one behind, and the sheep and black goats following in a long line, one by one. The Syrian sheep have very peculiar tails, hanging loose from the middle of a great round cushion of fat. It is very interesting to see the sheep all going after the shepherd, as of old, though I fear that, from the big stones thrown occasionally at a straggler, some of them are hirelings. The good shepherd now encourages his flock by talking to them, ' ow, aow, aow, aow, kik, kik, kik, kik, kik, tchè, tchè, wehke, weehke, chke, iz, uzz, iz, sz, sz, sz, sshh, sshh, sshh, sshh, ow, ow, ow,' and so on. I copied it down *verbatim*, so it is quite correct. The ' weehke' is a deep, deep, deep guttural, pronounced rather below the pit of the stomach.

" In the course of a few months a Dr Barclay, an American, who left the day after Hunt and I arrived, will publish a work on Jerusalem, which will probably be very valuable.

He has devoted some years to the deep study of the town and neighbourhood, and has had opportunities of seeing and exploring the Temple, which no Frank has ever had. He and his two sons were employed by the Turkish architect in assisting him to repair the mosques; and they spent a month or two in taking exact plans, measurements, and drawings. Under the mosques are very extensive remains of old Jewish architecture, large reservoirs of water, with all the pipes and apparatus that anciently served for the use of the Temple. We lost much by not seeing him, for they say that no one was so well acquainted with Jerusalem as he.

"And now to your letter. I was very grieved, for his family's sake, to hear of Mr C——'s sudden death; for himself, he has been spared the walking through the valley of the shadow of death, which is a great privilege. If, please God, I can continue as I have begun, I have great hopes that my Jerusalem pictures will be my best. They have my whole and undivided thought, and I know that no one has even attempted to study it as I am doing; and I think no one is likely to do so in a hurry, considering all the difficulties. I build up a little theory of returning, but that depends on much besides myself. I shall probably only have time for one more letter from you, and then you must write by the French-Egyptian post. News filter in so slowly here, that we cannot find out whether the war is going on or not. The original cause, a fracture in the lath-and-plaster dome of the Holy Sepulchre, is still unmended. Greek won't let Latin, and Latin won't let Greek; so the Turk will do it, *Inshallah!* and in the meantime smokes his pipe. Tell B—— I have two or three beetles for him, so

small that you cannot see them. My probable plan is to go straight to Dinan, finish the sky and water in my Pyramid picture, and come over with things fit to shew in about a month after. My final decision will depend on my letters from home.—With kindest love to all, believe me, your affectionate brother,

"THOMAS SEDDON."

"JERUSALEM, *August* 3.

"MY DEAR E——,—I have as little novelty to write about as ever. I am working steadily morning and afternoon, and have done about half my large picture. I look with perfect dismay on what remains to be accomplished in rather less than five weeks; still I hope to finish. Should I not be able to do it, with every exertion, I fear I must stay one packet more — twenty days! which, however, would not be all difference; for if I leave on the 8th of September, I shall have to remain a week at least in the south of France, to paint some olive-trees, which do not grow in Dinan. *Nous verrons.* I feel exactly like Baron Munchausen's horn that he blew into during a hard frost in Russia, and not a sound came then, but when he got into a warm room it thawed, and the whole tune came out. I have been shut up so completely the last two months, that when I get back into the world, the whole accumulated talk will flow out in one continuous stream, and I don't know if I shall ever be able to stop.

"I hear that my Silwan neighbours, now that they have finished threshing, or rather treading out, their corn, are meditating a raid against a village named Bethsahor, near Bethlehem, with which they are at feud. They will go in

a body, and skirmish until they have killed four or five, when they will be satisfied, and retire; and then the Beth-sahor people will return the compliment. This is the fashion here; most of the villages are at feud with their next neighbours, and have it out after the harvest is finished. I hear that the way they fight is to put the women in front, and then the husbands creep up, and fire from behind their wives, who scream and vituperate their opponents, because no Arab will kill a woman if it can be possibly helped. I think it is rather a good idea, and shall remember it in cases of danger for the future. All this does not prevent the country being considered in a very quiet and peaceable state, for in their feuds they never meddle with Europeans; and the other is merely the every-day state of things. Old Ibrahim Pasha was the only man who kept them really in order. By the by, you will have heard that Abbas Pasha of Egypt is dead. He was a sensual, bigoted Turk, of the old school, who hated all improvement, so that Seid Pasha is likely to be a much better governor for the country.

"*August* 13.—. I had an event last Friday. I went to a tea and water-melon party, at the Rev. Mr Beaumont's, whom we met at Cairo. The conversation was, much of it, about Jews, especially as one was to be baptized to-day, and a whole family shortly. They are a very singular people, and make very shrewd observations often in argument. There is one very curious reason that they give when they are asked, ' Why, if their religion is so superior, they do not try and bring others over to what they believe to be the truth?' They say, 'That their religion has already been offered to, and refused by, other nations; for

the Talmud relates, that when God wrote the two tables
of law, He first took them to the Moabites, who said that
they would look at them and see ; but when they came to
" Thou shalt not steal," they said that that sort of thing
would never suit them, and they would have nothing to do
with the commandments. Then they were shewn to the
Arabians, the descendants of Ishmael ; but when they came
to " Thou shalt not kill," they said that this would not do
at all for them ; and so the two tables went the round of
all the other nations, till they came to the Jews, who said
that they would take them and keep them. Thus, having
once refused them, the Gentiles have no right to expect a
second offer.'

"I do not know if I told you that we have come here
just at a crisis, when the European Jews, alarmed at the
proceedings of the mission, have sent over a Mr Cohen to
examine matters. His first step was to lay a heavy curse
upon any Jew who held any communication with Christians ;
and Hunt, who had spoken to some about sitting to him,
was put under a special curse. He called on Cohen, to ex-
plain that he had no connexion whatever with the mission-
aries, and that his object was purely an artistic one ; and
that, even if he wished, he could not convert any, because
he could not speak a word that they could understand.
But long before he could say all this, Cohen burst into a
most ungovernable passion, and stamped, and railed against
Christians till he was breathless. The effect has been, that
not a soul has dared to come near the house, which has
made him lose the whole month. However, Cohen left
last week, and one man has come, and I hope others will,
for poor Hunt was beginning to despair of being able to

paint figures here; and, indeed, between fanaticism and incurable laziness, it is extremely difficult. Last night, just before the gate of the town was shut, I saw a party of Jordan Arabs loading their camels. They were the wildest figures I ever saw, especially the women, who strode about in masses of dark blue drapery, with their wild black locks hanging over faces burnt almost black by the sun, and half hidden by a great blue floating drapery, rather than veil, retained on their heads by a rope of black camel's hair, and streaming in the air behind them as they moved. They looked like demons in the red twilight.

"We are in total ignorance about the war. To-day there is a report about Sebastopol being taken; but what is certain is, that the Moslems wish that they had accepted the Emperor of Russia's demand at first, for they say that he never asked for nearly as much as they will have to grant to their good friends and allies; and they cannot bear the Christians being made equal to the Moslems.—Believe me, most sincerely yours,

"THOMAS SEDDON."

"JERUSALEM, *September* 4, 1854.

"MY DEAR E——,——. . . . My long and weary banishment is now nearly over, and I am too happy at the thought of returning, to revert to past cares. *Dieu dispose de tout ce que l'homme se propose.* When I wrote to tell you I must stay three weeks longer, I never was better nor stronger in my life; but three or four days afterwards I had a slight attack, such as almost every European in the place has had more or less—the penalty, I believe, of the magnificent grapes and water-melons. If I had at once given up work

for a few days, I should have been all right; but I did not want to lose time, and went on working, so that at last I had to lose several days entirely; and though I have, thank God, recovered now, I have not been able to work hard this last week, and am in great perplexity, not knowing exactly what to do. However, I shall shortly see if I can finish in time for the next boat; if I cannot, I shall then take a week's holiday, which I have not had since I arrived, and go to Bethlehem for a change, and come back with fresh energy. I have had the consul and one or two parties down this week, to look at my work, and they all say that no one has ever come to Jerusalem and painted like it, and I have no doubt that they will write to influential people in England who take an interest in Jerusalem, and direct their attention to my picture.

" The great heats, which, by the by, I never found very hot, are gone now, and the weather is delicious; the evenings from five o'clock are very fresh, and the nights cold. There is not a flower to be seen here, for the summer without ever a drop of rain has burnt them all up, and the grass on the ledges of rocks on the hill-sides is become of a deep amber colour; but I believe that the banks around where my tent is pitched were a most lively sight in the spring. Mr Crawford called the other morning, and said that he never saw such a profusion of wild flowers in his life—hyacinths, convolvulus, and cyclamens in immense varieties, and creepers hanging in festoons over the mouth of the caves. I shall try and bring some roots of cyclamens, for they say that they are superb. Just now the pomegranate-trees in the valley look splendid, with their glorious golden ripe fruit hanging on the branches. The little triangle

below my tent looks like a jewel of emerald lying beneath
the three gray hills with their sun-burnt foliage; for the
waters of the Fountain of Siloam flow in little runnels
through all the gardens every day, which makes everything
grow most luxuriantly. Hunt went with two other gen-
tlemen the other day to a very beautiful valley called Wady
Phara, about eight miles to the north; there is a stream
running through it, and its banks are a wilderness of tangled
verdure, with fine bold overhanging rocks on the valley sides.

" Mr Graham photographs, and I shall see his views in
a few days. I hope to bring some of them to England
for him, so that I shall be able to shew them to you and
supply my own want of sketches. They are extremely va-
luable, because perfectly true as far as they go; however,
they will never supplant the pencil, for there is much in
photographs that is false; the greens and yellows become
nearly as black as the shadows, so that you often cannot
distinguish which is shadow and which grass. I told
you when I first came how untrue all the engravings I have
ever seen of Jerusalem are, but I scarcely knew how incor-
rect they were until now. In the books on Syria published
by the Christian Knowledge Society, very few of the places
are recognisable, and many are entirely false. I found in
one of their books the same woodcut put as a representa-
tion of two several towns. I intend, when I return, to write
to them, and protest against their pretended ' Christian
knowledge,' which is most unchristian story-telling.

" Three days ago was the beginning of the Bairam, the
great Mohammedan festival, and everybody was *fantasee_
yahing.* My boy walked off at seven in the morning with-
out saying a word, for which I fined him three days' wages.

It is a great time also for marriages, &c. Yesterday there was a grand field-day, which I happened to see, as it all passed close under my nose. There were three *half* couples visible, for the better halves did not come before the public. I was quietly painting when I saw all the population of Silwan assembled in the open space in the valley, and gunshots every minute shewed that something important was going on. In about half an hour they got into order, and moved in procession across the valley, firing their guns and pistols as fast as they could. When they came to the Pool of Siloam, opposite the village, there was a regular salute from twenty or thirty persons who were drawn up there. As it was half-past five, I considered myself justified in striking work, and coming to look; for the rock in front of my tent is just over the road about thirty feet perpendicularly. It was a very pretty sight as they came round the bend from Silwan; for the high bank over the road was covered with men and women, dressed in their best, and in that rare article, clean white shirts, and their best scarlet and gold turbans. Some of them looked magnificent fellows, like the old crusading knights. The women were gorgeously attired in blue gowns striped with red and purple, with large pieces of coloured silks embroidered on the sleeves and breast, amber being the favourite colour. The young Shekh, and two or three on horseback, led the way, and then came the bridegrooms on horseback. One of these was only about twelve years old. The crowd followed, shouting and firing muskets the whole way. In the middle they carried the brides' dress and head-gear, veil, &c.—in fact, the whole *trousseau*—flourishing it about on a high pole, like a great doll, while some men danced with drawn

swords in front, and all the children were running about frantic with delight. When they got to a large square space where they thresh the wheat, in front of the Well of Enrogel, they stood in a circle, and the horsemen galloped their horses about, the others firing their guns close to the horses' heads· or tails as they passed. There was a Turkish Effendi, with his servant, riding by on a splendid mare, who went in for a few minutes and beat all the Silwanee horses hollow. After this they adjourned to the village and had supper, and then sat in a huge circle, singing to the accompaniment of a drum and fiddle, and burn-ing powder all night long nearly. I walked up in the evening to the Mount of Olives, and on returning fired a salute from my revolver, which pleased them extremely. They sent me up some cake—a sweet sort of paste, cut into strips, and plaited and tied into all sorts of true lovers' knots, and then baked. Really the ceremony is so uncommonly fine that I think I must get married at Silwan.

" 6th September.—I am glad to say that I have been able to work well the last three days, and if I can go on so without a check, I shall get off in three weeks, but must leave it uncertain. I am heartily weary of my hill-side, and have no new events to tell you. We hear nothing of the war; I believe that when it is finished, Turkey will gradually fall to

pieces from the corruption of the governing classes. In this town the Pasha receives six thousand pounds a-year to put him above bribery; and yet he takes bribes from every one, and justice is sold in turn by every Effendi in Jerusalem. An Arab Shekh, south of Hebron, offered a large sum to the Pasha to shut his eyes to what he did, and in fact to let him rob everybody, except Franks I presume, and actually came to Jerusalem a few weeks ago to arrange terms with the Pasha. However, Consul Finn heard of this, and sent word to the Pasha that if the man ever went back to Hebron he would write to Constantinople, and state the whole transaction; so our poor friend is done, and has been obliged to send for his family to come to Jerusalem. The consuls do not get him dismissed—because, in the first place, he has sent a very large sum of money and bribed the heads at Constantinople; and, in the second place, in getting rid of him they may get somebody very much worse. This is the state of things I believe throughout the Turkish empire. I am to dine one evening this week with a Turkish Effendi, which I shall be glad of, as it will be the first time I have dined with a native gentleman.—Hoping soon to speak, not write to you, believe me most sincerely yours,

<div align="right">" THOMAS SEDDON."</div>

<div align="right">" ACELDAMA, September 18, 1854.</div>

"MY DEAR MISS S——,—Having just discussed my chops, rice, and betinjan (the fruit of the black egg-plant, which, sliced and fried, I commend highly to your romantic palate), and further agreed with Tennyson—'Oh! who would fight and march and countermarch,' be shot for sixpence in a battle-field, and shovelled up into a bloody

trench, where no one knows? oh! who would cast and
balance at a desk, perched like a crow upon a three-legged
stool, till all his juice is dried up, and all his joints are full
of chalk?—I began to meditate, seated on the wide-spread-
ing roots of my almost apostolic olive-tree, that I have a
debt to pay in answer to your kind letter, which quite
transported me back into civilised life and comfortability,
as I read of —— being again inhabited, and J—— going to
Westminster; all which I congratulate you upon very much,
it being, as I think, much better than any French educa-
tion; and 'the baby being like his father' (as all babies I
ever heard of invariably are). I never catch sight of a baby
here; they are all in a square cloth, hanging down the
mother's back, suspended either from the forehead or neck;
and they never interfere with anything—even their crying
must be smothered in the bundle, for I never hear it. The
veil, if you can make it out, hanging down her back, is a
very substantial piece of white
linen, two yards long, and a yard
broad, fringed at each end; so that
Ruth could have carried a good
supply of corn in it. The Fella-
hin and Arabs have not retained
any of the chivalry of their old
crusading enemies; for you see a
woman toiling along, with her baby
hanging behind, and an enormous
burden on her head, while her hus-
band, in all the pride of the nobler
sex, rides majestically upon a don-
key in front, with his gun slung round behind, and his toes

touching the ground. By the by, there is a new style of seat for sticking on, which I saw in Jerusalem yesterday; I recommend it to your nephew.

"As you have seen my letters home, I shall not describe Jerusalem, except to say that until I came I had no idea of what it really is, as I have not seen one correct engraving of it. I cannot yet judge of Roberts's, as I have not seen them. *Quant à la société*, it is all clerical and consular, with several very nice people individually, but more party disputes than any place I ever heard of. The result of my personal experience in seeing these missions is, that I shall advise everybody to do good at home to the thousands of English poor, who are without teachers or comforts, and where they may be tolerably sure that their money is usefully employed.

"I shall be obliged, I fear, to remain another three weeks, for I became very unwell, and was quite unable to work, and neither I nor the Hakim could discover why, until one day I said, 'How nice the water of Silwan is,' when he said, 'That accounts for everything. It contains sulphate of magnesia, and I know not what else.' So that I had been quite unconsciously taking a dose of medicine every day, and may be thankful it was no worse. It is now ten days since I left it off, and I am now quite strong again. I think, if all goes well, that the result of my year's work will be very satisfactory, and especially that of the four

last months at Jerusalem. All my paintings here are far better done than anything that I have ever done before, and I think that their own interest will attract attention towards them. It is tolerably clear now, that with God's blessing I may calculate upon a moderate income, which I felt painfully anxious about before. I thank God most sincerely for having been enabled to do what I have done ; for, except once from imprudence, and this time from ignorance of the medical quality of the water, my health has never flagged, though I have worked much harder than most people do in these climates. I must say that I enjoy it, and have never found the heat uncomfortable, especially in this high hill-country, where there is always a fine fresh breeze. I took, last week, a trip to Hebron, and though, through the want of punctuality of two of our party, I did not see it, I gained my object in quite shaking off all indisposition, and being able to work hard again as before.

"Mr Sandreesky told me the other day an interesting circumstance—how the lives of some missionaries were saved by their being seen praying. He said, that when he first came to the East, with another gentleman, finding that the Moslems do not retire into private when they pray, but address themselves to God wherever they be, and that this is not a matter of ostentation, and that from never seeing Christians pray they think that they have no religion at all, he and his friend determined to follow the habits of the country, and every morning and evening to read the Bible and pray openly. He was stationed at Mosul, and having to go to another station, he took the direct road through the country of the Koords, though it was said to be very dangerous ; and it so happened that everything was at that

time very peaceful, and he went through without inconveni-
ence, and returned by the same road. About a year after
this, two other missionaries were to go to the same station;
and, as Mr S. told them that the road was quite safe,
they went by that route; but just then the country was
rather disturbed, and the Shekhs were jealous of the Turkish
Government, and looked very suspiciously at any strangers
coming into their country; so that they had not gone far
before they were warned not to continue by that road, for
the Shekhs would be sure to stop them. However, they
paid no attention, but went on. Every day they found
more and more difficulty, and on the fourth day they saw
that they were in great danger. It was, however, too late
to turn back, and they came at night to a village where
several of the Shekhs had met with their followers, and
there they were told that these Shekhs intended to kill
them. There was no help for it, so in the evening they
read and prayed as usual. It so happened that the Imaum
of the village saw them, and was much surprised. He said,
'These men are not infidels; they pray to God,' and he
went straight to the Shekhs, and said, 'I take those men
under my protection; they are holy men, for they pray to
God: you shall not kill them.' The Shekhs insisted, but
the old priest held firm, and they were saved. They were
pillaged a little, it is true, but sent safely back by the way
that they had come.—Believe me, yours very
sincerely,

"THOMAS SEDDON."

" JERUSALEM, *September* 21, 1854.
" MY DEAR E——,—When I last wrote I hoped in-

deed it was the last letter I should write to you from here; but the very day after posting it, my old enemy, which I thought I had staved off by half-measures, returned, and I was obliged, sorely against my will, to lay up regularly. It is a fortnight ago to-day since I struck work, and though I have now, I hope, got entirely right, I have only got to work again during the last three days, and have been obliged to be very moderate and not to tire myself, for the Sirocco has been blowing for the last four days, and the barometer is 80 deg. at night, and my Egypt experience has taught me to be careful. I hope it will change to-morrow, for it seldom lasts more than three or four days. I do not dislike it so long as I am sitting still, and it is nothing compared to the Egyptian Khamseen. Unless I am to abandon all fruits of my banishment, I must stay another three weeks, that is, till the 19th of October. It seems to me like the fifty daughters of Danaus filling the tub with holes in the bottom; it looks as if I should never get off. However, I stick to my old work, and hope to complete my two pictures and two water-colours satisfactorily.

"I spent my invalid week at a little square stone tower, like a feudal castle, near the top of the Mount of Olives, which Mr Graham, the secretary to the mission, has fitted up as a summer retreat, for there I could lie on the sofa and have the cool breezes all day; and being vaulted with solid stone, it is very cool. Jerusalem lies like an open map before you, quite carrying out the description of the Bible of its being four-square, for it is as nearly square as possible. Graham is kindness itself, and left his horse when I got better, so that I might take a turn in the morning and even-ing. I spelt through all the newspapers that could be

scraped together in Jerusalem, and got a wonderful insight into the doings on our planet.

" *September* 26.—Since I last wrote I have an event—a most precious material for a letter : a journey to Hebron, about twenty-five or thirty miles south, where Abraham encamped and David reigned, and which is surrounded by the most fertile valley in Palestine, now one luxurious mass of vineyards. On Friday at two o'clock, Hunt sent down to ask if I would join with himself, Graham, and Sim, surgeon to the hospital, in a trip to Hebron, to start that afternoon and return on Monday. Thinking that the change would quite set me up again, I agreed, and I am all the better for it—indeed as well as ever. . . . However, to my story: I went up as soon as I had got my traps ready, and Graham told me that the journey was postponed till next morning; on which I declined going, as I thought seven or eight hours on horseback would knock me up; so he lent me his horse, and after fifty delays I started and rode to Bethlehem before black night was on. I spent the evening with the Austrian consul, who is staying with his family at the convent, and at seven the next day Hunt and Sim appeared. Graham found out, just as they were starting, that he must go up for his revolver to the Mount of Olives ; so they came on first. We breakfasted at Urtass, two or three miles from Bethlehem, where a converted Jew, Meshullam, has built a house and made gardens. It is a long winding valley, with a stream from Solomon's Pools running through it, and it is the site of his celebrated gardens. You see there what can be done in this country with care and water. The standard peaches are one mass of fruit, breaking down their branches with the weight, and grapes and figs in wonderful abund-

ance. The green crops are rank. They sell peaches as
large as your double fist at six pounds for sixpence. They
gave us a noble breakfast, and we waited till nearly eleven
for Graham, and then started, as we thought that he had
taken a shorter cut. We were about half an hour getting
to Solomon's Pools, for one of our party had a knapsack
tied to his saddle with two pieces of tape, which broke
every few minutes; then he dismounted every ten minutes
to alter his saddle-girths, which he contrived at last so well
that he slipped going down hill on to the horse's ears, and
at every ascent on to the tail; and as our path lay over and
among rocks that in England are generally reserved for wild
cats and goats, this was happening every minute. I was
very much pleased at seeing Solomon's Pools; for they are
huge works—the upper and nearest as long as, and wider
than the whole of your Dinan 'Grande Place,' the second
and third smaller. They lie about seven miles in a direct

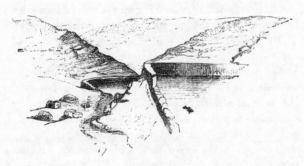

line from Jerusalem, and used to supply it with water; in
fact, the aqueduct was put into order six years ago, but the
Fellahin broke holes in it, to save themselves the trouble

of taking their cattle to water. They are now once more repairing them, and I hope will use them again next year. A Turk here put the offending saddle in order, and we went on picking our way through the rocks, and getting a gallop occasionally when there was a straight piece of path in the valley, and so made the best of our way. As we went on, the hills became more and more covered with brushwood, and remains of old stone houses shewed how it had been once inhabited. As it was, not a soul was to be seen for miles together, and scarcely a bird; but we passed through some gloriously picturesque valleys, and the hills, though so bare around Jerusalem, were here covered with green bushes, with the gray rocks dotted about among them. They are all large, rounded, swelling masses, like huge bubbles.

" We got to the mouth of the Hebron valley about three miles before coming to the town, and here the whole country is a mass of vineyards, terraced to the hill-tops, with square stone towers—the clusters of grapes, eighteen inches long, hanging down to the ground. We stopped at the entrance of Hebron for a while, waiting for one of the party who had fallen behind, and we spent the time in eating grapes. It was now half-past five, and no baggage had arrived; so we rode into David's ancient city, and took our horses into the court of a Turkish coffee-house, where Sim the Provident made some tea. He had put a packet into his pocket, and stakes his reputation on his tea—Howqua, flavoured with orange pekoe. We then, with difficulty, extricated ourselves from backsheesh-seekers. One old hag bothered me so, that I sent her to Sim, and Sim to Hunt, whom she finally seized, and would not let go, till Sim declared he would shoot her; and she was in a great rage, and we laughed

at her rueful faces. We now went back to see if Graham had come, for he had the tent and provisions, while we were houseless, and loitered about till eight o'clock. During this interval I made an excursion to try and get some milk. I found an Arab watching grapes, who led me nearly a mile, over hill and rock, to a shepherd; but when I got there the milk was all gone, so I had to find my way back as well as I could. As it was now dark, and no Graham, we went back to the town, and at last got lodging in a Jew's house, which having been just whitewashed and done up for the feast, looked very clean. He gave us a capital supper, with the most beautiful bread I ever tasted; I never saw any in either England or France to compare with it. At ten o'clock three Fellahin came with a note from Graham, telling us that he was under Abraham's oak, two miles off. It appears that he had got there at five o'clock, and, instead of sending into the town at once, first pitched the tent, and had tea; and there we were looking out for him all the time. I was so tired, after eleven hours on horseback, that I remained in town; but the numerous enemies prevented all sleep, and at daylight I walked out to the bivouac. After breakfast they went into the town, but I staid and slept in the tent, and afterwards made a sketch of the gigantic oak, which is said to be the one under which Abraham pitched his tent. Whether this be true or not, it is impossible to say; at any rate, there is little doubt that under its branches the Romans held a fair after the destruction of Jerusalem, and sold the captive Jews. It measures twenty-four feet round the trunk, five feet from the ground, and is sixty feet high, with a magnificent head of foliage.

"In the afternoon, before sunset, we climbed the hill to

the west, and, over ten miles of mountain-tops, looked on
to the Plain of Sharon stretching to the sea. As I could
not spare time, after what we had lost, to make a good
sketch, I started with Sim at seven in the morning, and
rode in the cool of the morning to Jerusalem, where we
arrived at half-past twelve. Hunt and Graham, with the
servant, were to have started at twelve ; however the gates
shut at night, and they had not come. They made a pretty
mess of it. Hunt was not ready till four, and then Graham
found that he had no small change, and they rode back
into the town to get some. Then they found that they
could not carry the photographic apparatus without a don-
key. When that was got, they thought it would be a good
plan to balance it with some grapes. They then went half-
way back to the town to water their horses ; and finally
left, with an Arab, at half-past six, and lost their way in
the dark, and got two hours' distance out of the way on
the road to Gaza. They suspected that they had gone out
of the way, and looked for the north star ; but here there
was a difference in opinion : one chose Jupiter, which hap-
pened to be due south, and the others each took a pet of
their own. Fortunately, Graham had a small compass,
but they had no little difficulty with a flint and steel in
getting a light to see it. At last they got to Bethlehem at
three in the morning, slept there two hours, and arrived at
Jerusalem at seven, just as we had finished breakfast. Al-
together it was a pretty little adventure. I made a sketch
of the search for the north star, which is making me a
great reputation at Jerusalem.—Believe me, most
sincerely yours,

"THOMAS SEDDON."

The series of letters from the Holy Land may be fitly closed with the following, addressed to the Rev. T. F. Stooks. It gives a *resumé* of the writer's impressions, and explains the motives which had so long detained him at Jerusalem :—

"If I had more time, I should have written earlier, and also have written a longer letter than I can find time for now. You have heard of my movements from home, and I know the kind interest you have taken in them ; but, indeed, when I am once settled in a place, the monotony of daily work gives me little opportunity of filling an interesting journal, like most travellers. I go to see nothing that has not a special reference to my object ; for I have neither time nor money for sight-seeing, and did not come out to enjoy myself. When once I have chosen a spot, I sit down there for a month or two, seeing no one but the peasantry around me.

"Egypt interested me extremely, and reports, which turned out to be false, of the insecurity of Syria detained us there longer than we had calculated upon. Now that we have come here, we regret extremely not having come earlier. Jerusalem and its neighbourhood require a residence of two or three years to do them any justice. Independently of the undying interest of its associations, the country round is extremely beautiful. The view of the Dead Sea, with the long range of Moab mountains, is the most striking I have ever seen ; they are now half-veiled by a thin vapour, through which the sun gilds every projection, while the deep shadows, softened by the mist, give it more the appearance of a mysterious cloud-land and a

vaporous unreality, which make you doubt whether they can be solid earth like the nearer hills. This will last, I am told, the whole autumn. In the spring, I believe, they are clear and sharply defined, as if close at hand. I long to go to the Dead Sea, whither Mr Finn, the consul, has offered to accompany us; but I must not. The influence of the place is very great. It is impossible to look daily on the slopes of Zion and Olivet without feeling that one treads on holy ground. I think that I am very anti-sentimental, and had thought that travellers worked themselves up into a fictitious rapture at Jerusalem, and that the great truths of the Bible should be felt as strongly in England as here, and had, therefore, determined not to fall into raptures; but when I came in sight of Jerusalem, I never felt so sudden a revulsion of feeling as when I saw the very ground on which Christ had lived a life of poverty and neglect. It no longer seemed a tale of two thousand years ago, but His sufferings and agony and death for me and sinners became such a vivid reality, that I could scarcely help bursting into tears. I hope I may be able to return to this place; for to assist in directing attention to Jerusalem, and thus to render the Bible more easily understood, seems to me to be a humble way in which, perhaps, I may aid in doing some good. I am sorry to be obliged to return (I speak with reference to professional views) just as I am qualified to benefit by the much lost time which is inevitable in beginning to travel in a country so different from our own. I know enough Arabic now to live among the Arabs without a dragoman, and could perfect myself very rapidly if I gave any time to the study; but the future is in wiser hands, and at present I try to do my daily work,

and leave to-morrow till it comes. But there are some grave questions as to my future plans, which I must settle soon after I return. As long as I remained a single man, my professional prospects were amply sufficient for me ; as I had quite renounced all wish, in fact, to live differently from my life of the last two years. But although I think I feel fully that God will provide all that is necessary for me, and that my success in money matters the last two years has been beyond my most sanguine hopes ; yet I know that my past success has not been earned by merit. Two schoolfellows were good enough to give me commissions ; but the public know nothing of me, and I have yet to learn how they will appreciate my works. I have also great doubts as to the motives which led me to give up business. I hated the drudgery of the one, and liked the freedom and the pursuit of the other ; in fact, as far as my new occupation goes, it is almost unmixed pleasure ; but I fear it was not a little selfish. I know, too, that I had no high motives of wishing to do good, but simply that of following a pursuit I delighted in ; therefore, altogether, I feel that I do not deserve a blessing on it : though now I hope I look on it with other views, and think I see many ways in which it may be made subservient to good. . . . I am sure that there is a great work to do, which wants every labourer —to shew that Art's highest vocation is to be the handmaid to religion and purity, instead of to mere animal enjoyment and sensuality. This is what the Pre-Raphaelites are really doing in various degrees, but especially Hunt, who takes higher ground than mere morality, and most manfully advocates its power and duty as an exponent of the higher duties of religion. Indeed, I think that our intimacy is a

most valuable and useful lesson to me, for which I may thank God, and by which I hope to profit much myself; for he has the courage to say openly what he thinks right.

"I find that there is a regular English society here, and among them some valuable men; especially the Rev. Mr C——, whom we both like very much—altogether a superior man, and so pleasantly enthusiastic and genuine. He frequently pays me a visit, and has lent me a volume of old John Foxe's Works. I am reading his sermon on Christ crucified, which I am much pleased with.

"You will have heard from home that I have encamped in an ill-sounding place (Aceldama). From my tent I look over the King's Gardens, right up the Valley of Jehoshaphat. The consul thought the inhabitants of Silwan unreasonable in their demands for watching my tent by night; so I am doing without any guards. My servant sleeps across the tent-door in approved fashion, with our pistols, &c. in readiness, but I think more *in terrorem* than anything else. If I can finish in a month's time, I shall adjourn to Olivet, and there paint a view of the town from Scopas, and the view of the Dead Sea.

"The country is disturbed near Nazareth, from a feud between two families; but they do not molest Europeans. Jerusalem itself is quite quiet, and I should think, since you saw it, almost rebuilt. Substantial stone houses are rising every day, and the rubbish-heaps and waste places are rapidly disappearing. Nicolayson says it is quite a different town from what it was a few years ago. I must conclude, hoping to see you soon.—Believe me, most sincerely yours,

"THOMAS SEDDON."

CHAPTER VIII.

THE term of his weary banishment at last was over, and having brought the several pictures he had undertaken to a sufficient state of completeness to warrant his leaving the East, he gladly seized the first opportunity of returning. He went first of all to Dinan, whence it will be remembered that he started, and where in truth his heart had been all the time of his absence. He remained there about two months, finishing some parts of the foregrounds of his paintings. The following extracts from letters written from that place give some particulars of his homeward journey, and of his subsequent plans and proceedings :—

" DINAN, *November 5*, 1854.

" MY DEAR MOTHER,—I arrived here yesterday, after a most prosperous voyage. I left Jerusalem on Wednesday morning, October the 19th, before daybreak, and arrived at Jaffa after a twelve hours' ride. The next day I went on board the French steamer, and had fair wind and weather the whole way. We got to Alexandria early on Saturday, and as I found that Mr Bruce was up from Cairo, I called upon him at the consul's, and dined there in the evening.

I

We left Alexandria on Sunday afternoon, and after coasting all along the south of Crete, which is a barren but picturesque mountain range, arrived at Malta at six on Thursday morning. The town is most imposingly situated on a high rocky island, with a harbour on each side, and the view from the upper batteries is very striking. We heard no news of the war. Troops are passing daily, and we started at twelve, bringing two convalescent French infantrymen who had had cholera at Varna. I landed at Marseilles on Monday, and left next morning for Paris, with an Englishman whom I met on board the ship, an honest, rough seaman, the head of the dockyard at Bombay, who cannot speak a word of French, and therefore desired my escort. I only stopped a day in Paris to execute some commissions, and buy some colours and etching tools, and then came on here. I thank God sincerely for the success and progress I have made the last year, for on that point I think there cannot be any doubt.—Believe me your affectionate son,

"THOMAS SEDDON."

"RUE DU MARCHE, DINAN,
November 10, 1854.

" Many thanks, my dear brother, for your kind letter, which I got at Paris. Indeed, I must appear very absurd and changeable, but I am not so. To feel a life's happiness hanging on the result of my poor hand's work, with the thousand difficulties, with illness and with the fear of it—to work on constantly without seeing a soul, for at Jerusalem I never saw a Christian soul except on Sundays—is enough to make one anxious. Hunt could not understand my not

sacrificing everything to art, and conceived a very mean opinion of me, when, after fruitlessly urging me to stay and entirely complete my picture, I told him that I would toss all my pictures into the fire rather than stay a moment over the time I had fixed. I set to work directly I got settled here, and hope to bring over almost everything thoroughly completed. I shall also bring with me good letters of introduction."

He left Dinan in January 1855, having, during his stay there, so far forwarded other work besides his paintings, that he had become engaged to be married—an event which the reader may perhaps have been led to anticipate, from some of the foregoing correspondence. On his way from Dinan to England he stayed a few days in Paris to paint a figure into one of his smaller pictures, as will be seen from the following extract :—

"PARIS, *January* 4, 1855.

"I have been very fortunate in finding an Arab, from whom I have been painting; and I hope to finish from him my Shekh, and the figure in the unfinished picture with the palm-trees. He fought for twelve years with Abd el-Kader, three years with another chief, and lastly with Bow Maza, was taken prisoner, and was released by Louis Napoleon a year or two ago. He has received thirteen wounds, from which he is only now recovering. He is a very handsome and fine fellow, and as superior to the Eastern Arabs as education to ignorance. He says that they have in Arabic all the history of the English and French wars, and those of Spain—things that the Egyptians are perfectly ignorant

of. He seems to like the English very much, and says that
Abd el-Kader was often assisted and supplied with arms
from England, and that some English officers came and
joined in some of their expeditions against the French."

Having arrived in England he set himself to prepare for
the exhibition of his works in the ensuing season, and the
following letters will shew with what measure of success.
These letters have a further value, as shewing how practi-
cally and fully he had now made Christianity the rule of
his life, and how, though naturally anxious to obtain pro-
fessional distinction and position, there was now in his eyes
but one thing absolutely needful.

"27 GROVE TERRACE, KENTISH TOWN,
February 16, 1855.

"MY DEAR E———,—I have never forgotten to pray to
God to guide and help you, as I believe you do for me, and
I have asked Aunt to pray for us; for if the fervent effectual
prayer of the righteous availeth much, hers must be a great
treasure. We may look on her as a tried and proved Chris-
tian, whose advice and example are equally precious. I am
but a beginner in the right road; yet, in what I say, I trust
I am sincere. Years of sin, and old bad habits, are
struggling hard to pull me back; and without God's mercy
to me of late, I should long ago have fallen back again.
But, please God to help me, I will not. Indeed,
as poor Guy said after reading Sintram, 'The life of the
best is but a long struggle against the powers of darkness,
on towards death; but victory is at the end, and a bright
reward at last.' You see I have been quoting the 'Heir of

Redclyffe.' I think Guy and Amy are charming, but Philip is insufferable, till one feels for him in his repentance. Poor Philip! when he says in his confession, 'I deceived myself; but these things will not do when we see death face to face. No, indeed; our excuses and veils of decency are all torn aside then, and yet conscience speaks just as plainly in health;'—only (I speak for myself) one is constantly quibbling with it, and finding some plausible reason for doing some part, perhaps most, of what it whispers is right, but just leaving out or glossing over some little point that we declare unimportant, and which interferes with our will or pleasure at the moment.

"I have heard from Dr Sim, at Jerusalem. He says he has shot me a grand eagle, four feet high, and eight feet from wing to wing, which he is sending over to me in a box; it will enable me to put a grand foreground into my small picture of Mount Zion."

"27 GROVE TERRACE, *March* 5, 1855.

"My DEAR ——,—I have been up to London last week and to-day, seeking for rooms, and now have two strings to my bow, between which I shall decide to-morrow; so that I can begin to sound the trumpets early in next week. The rooms that I hope to get would take the whole of your cottage into one of them. The sitting-room is about thirty-five feet by twenty, and a stupendous bed-room, with a grand footman in buttons to open the door, by which I expect rather to astonish the artistic world. It is in Argyll Street, close to Regent Street. I have painted into my Pyramid picture a sky with spikes of light beaming up (only more faintly than in the small copy you saw),

and some red clouds behind the Pyramids, all which is re-
flected in the water. 'Jerusalem' also is quite finished,
and much improved by a rather deeper blue sky.

"Enough about myself. As regards your complaint, it
appears to me that you want to feel at the outset the same
as those older servants of God, who have borne the burden
and heat of the day; but if Christian life is a race, you
cannot have made so much progress at starting as after
years of patient endeavour. Your very doubts and fears
would seem to prove that you are sincere in your wish, and
I think your own heart will allow, that with all shortcom-
ings, you wish to serve God; and if so, surely you are a
true, though probably a very imperfect Christian, and very
unlike what you would wish to be. But, indeed, God only
can put feelings of peace and confidence into our hearts;
and woe to us if we put them in ourselves, for then they
would only lull us into false security! I suppose that a
deep feeling of our own unworthiness is by far the safest
feeling for sinners to have; and, indeed, I believe that our
feelings are very much dependent upon our temperaments,
and that many very eminent Christians, who have been of
essential service to others, have yet had most distressing
doubts and fears for themselves, which have not left them
till late in life, or even at death's approach; and some, whose
real piety none could doubt, have never experienced those
feelings of joy and comfort which others do."

"KENTISH TOWN, *March* 10, 1855.

"MY DEAR ——,—I little thought what an exertion it
was to you when you wrote a fortnight ago; and, hoping
you were getting better, I thought it was my duty to go on

with my plans; and so I have taken rooms in Berners Street, Oxford Street—not the magnificency I spoke of, which I now regret, for I should have been more comfortable; but I have still a very good room, with a good light, papered with a dull green paper, to suit and improve the tone of my pictures, and for all practical purposes it will do very well, I fancy, and is perhaps more professional than my palace. I am to go there next Wednesday, and after Saturday shall be prepared to see people. I shall have to be horribly busy, writing notes and making calls, and soon I shall know the result of my year's work, and my future prospects. The time (in the midst of war) is not favourable, and I shall not be astonished if my success is less than it might otherwise have been; but I try to leave it, without anxiety, in God's hands. I have this week finished the shirt and sandals of my old Shekh, and spent all yesterday in placing the great eagle for my picture of Mount Zion. To-day I have been trying to draw him, but without succeeding in satisfying myself; however, I hope to do better on Monday.

"We had a letter from L. the other day, saying they had heard of the death of the Emperor of Russia last Sunday on coming out of church. It strikingly shews what a frail vessel contains even the firmest mind; and the master of half the world might well have done as Saladin of old, who made his standard-bearer carry through the streets of Damascus his winding-sheet, proclaiming, 'See all that the great Saladin, conqueror of the East, carries off with him of all his conquests and treasures.' With all his faults, Nicholas was a great sovereign, and I think we may charitably hope that he carried out what he conceived his duty.

Certainly his life was not one of sloth or self-indulgence, but of stern and resolute application to the duties of his earthly lot. The temptations of his position, as head of his people, and spiritual head of the Church, must have been greater than we can well imagine, and I for one am thankful that they did not fall on me.

"*Sunday Evening.*—Another winter is come. It has been snowing all the evening, and I think before morning we shall have a heavy fall; but as the wind is south I hope it will not last long, on your account and that of the poor horses. I often wish I could be with you on Sunday evenings; but as I cannot, I shall copy out part of one of good Mr Cecil's sermons, as I think it bears a little on your fears and doubts of yourself."

[Then follows an extract from a sermon on the text, "For thy name's sake lead me and guide me," Ps. xxxi. 3.]

"Is not this lesson of your utter weakness what God is teaching you now? and is not that the first step towards throwing your care upon Him who careth for you? You cannot be as holy and calm as Leighton at once; you must bide God's time and gift. There are door-keepers in the house of our God, as well as distinguished saints; and the longer and the more closely you serve Him, the more you will become like our Great Pattern. I cannot doubt the sincerity of your wishes; thank God for every good desire, but do not dishonour the Giver, by doubting the reality of the gift. But now I fear that by my writing thus to you, and quoting the words of good men, that you will be led to think me very different from what I am. Would to God I could feel as I ought what I write, and that my life were more influenced by what I know! But I feel the deep

roots of sin springing up constantly, till I almost doubt whether I serve God at all; yet when I compare what gives me pleasure now with what did three or four years ago, and remember how I neglected and deemed irksome any religious duty or thought, I cannot but see some change; and I trust that God has not sent me illness and trials, and now blessings that I did not dare hope for on earth, without intending to give me His assistance to profit by them."

"I cannot answer your letter to-day, for I am in the centre of a mountain of things to be done. Nothing was ready when I came in, not even the carpet laid down; but matters are arranged at last, and just in time, as I expect some visitors to-morrow. I have to put my pictures into their frames, and to hang them up; and to-morrow evening I am to give a select tea-party to some half-dozen of the more illustrious of my artist-friends. You may well say that no kindness can surpass Brown's; time just now is very precious to him, yet he comes every week, at least, to advise me.—Yours affectionately,

"THOMAS SEDDON."

"14 BERNERS STREET, *March* 19.
. . . . "Mr Ruskin also came and stayed a long time. He was very much pleased with everything, and especially 'Jerusalem,' which he praised wonderfully; and in good truth it is something for a man who has studied pictures so much to say, 'Well, Mr S., before I saw these, I never thought it possible to attain such an effect of sun and light without sacrificing truth of colour.' He said that my inte-

rior at Cairo was the most perfect thing that he had ever
seen, and admired the Turkey carpet as much as your
mother. . . .

"Imagine the good Leighton (whom you and I discussed)
being severely reprimanded and ordered to make a public
apology, when at college, for having written some verses in
ridicule of the Provost's red nose! We have just had a long
letter from my friend H. B—— in America. He speaks
of the cold there as something terrific: people were frozen
to death on the tops of the omnibuses; and some of the rail-
way trains were stopped, and the people burnt some of the
carriages for fuel; the thermometer from 16° to 44° below
zero.

"I am glad that you seem happier, and I hope a little
less perplexed and doubtful about your path of duty. I
always felt sure that God would make things clear for you;
at least, as much as is necessary for you to go on day by
day. Old Baxter was a glorious Christian man, in a trying
age; I have just got a little essay on him and his time,
which I think you will like to see.

"You ask me 'Whether it is our sin, or want of faith,
which causes fear of death?' Of course it is imperfection
of our faith. If we have really repented, our sins are
washed away in Christ's blood; but still it is a solemn
thing to go and stand face to face with our God. Elijah
covered his head with his mantle when the glory of the
Lord passed by, and even the angels behold the Lord with
holy fear. I hope we shall each do our best to lead
each other in the right path, to love and fear God, and to
prepare ourselves in this world for the next.

"I wish you could see how grand I have made my rooms.

My pictures are all on easels, very nearly filling the apartments. Over the mantelpiece I have suspended my yataghan in a silver sheath, ornamented with coral; my Arab spear, with a bronze medallion of Tennyson over; and a tall china vase, with two old Greek ones and an Egyptian one, on the mantelpiece, have rather a *recherché* look. Over the door I have a *trophée d'armes*, a long old six-foot sword, with a waved crease, and a Sikh tulwar from Sobraon. Opposite the windows I have hung a large drawing of Rosetti's, and a landscape of Brown's, with his portrait of my father. On the side-tables I have got an inlaid Eastern cabinet, which shall be yours if you like it, and some Eastern ink-stands, and Circassian kandjars. Then I have a small bookcase, with an elegant selection of books, so that altogether I flatter myself that I am pretty well got up; and the landlady is so impressed with my early rising, that I have been politely requested to ring the bell when I get up, to wake the house.—Yours,

<div align="right">" THOMAS SEDDON."</div>

" 14 BERNERS STREET, *March* 25, 1855.

" MY DEAR ——,— The weather has, I fear, not been very propitious for you. The last three days have shrivelled me up into an atomy, and quite account for my not having had many visitors; but my fame is creeping on. I hope soon to have something more substantial to tell you of. I have this Sunday copied you out a very eloquent passage from a sermon by my old London clergyman (the Rev. G. Drew), who used to please me greatly, and who is now, I am sorry to say, laid up by ill health. He is shewing how much more real interest we can take in the beauty and

grandeur of creation when we think of the goodness and love of our Creator. Often, when painting alone, in face of some glorious scene, glittering in light, or half-veiled in mystery, even when I was in truth very careless, yet I could not help exclaiming, 'How glorious is everything that God does!' I have begun reading your book, 'Far above Rubies,' this evening, and as far as I have gone, I think it very valuable, and full of good advice; and I think I can understand why you liked it so much, for it grapples with many of the difficulties of which you speak. I do not know if you still have the volume; but it strikes me that at page 38 there is a passage treating of the difficulty of feeling a real value and desire for holiness. Nothing can be more obvious than the constant connexion in Scripture between our own efforts and the blessing of God. Though God alone giveth the increase, Paul is bound to plant and Apollos to water. We cannot by our own efforts produce that holiness of heart from which alone a holy life can proceed; we cannot of ourselves acquire that relish for spiritual joys upon which our fitness for the inheritance of the saints in light depends. But while we pray to God to bestow these graces upon us, we may be diligently employed in removing what might prove obstacles to their exercise; we may 'lighten the ship,' though convinced that God alone can bring us safely to land. I am afraid that I rather over-sermonise in my letters; if so, tell me. I do not want to be a schoolmaster or doctor of divinity, but it is a new thing to feel really interested in the most serious things and objects, and I try only to say what I wish to feel.—Most affectionately yours,

"THOMAS SEDDON."

The following letter is addressed to his friend F. M. Brown, Esq. :—

"14 BERNERS STREET, *April* 2, 1855.

"Mr Arden, who has Millais' 'Release,' came to-day, and wanted to have Earl Grosvenor's Camel. I hope he will take the Shekh in white dress. My Camel is to be hung with two pictures by John Lewis, which is honourable company. I wish I had painted still more carefully. You will be glad to hear that I have sold my water-colour Shekh, and have a commission to paint at my leisure a repetition of my Dromedary, altering the figure of the Arab, and rather increasing the canvas." . . .

"BERNERS STREET, 1855.

"MY DEAR ——,— Your welcome letter arrived just at the end of a week, which has been more prosperous than I had hoped from the beginning. I was beginning to want one to put me in spirits. I find that in my anxiety to get over to Dinan, I have made a mistake, and sent out my invitations a month too soon; for very few people are in town, or will be, till after Easter. But the last three days several people have called, and on Friday Earl Grosvenor, who was sent by a brother artist who had evidently spoken very kindly of me, bought my picture of the 'Dromedary with the Arab lying down.' And yesterday he brought some friend of his, and the Duchess of Sutherland, to see my pictures. They stayed some time, and seemed very well pleased, and Lord Grosvenor said he would send some of his friends. But another thing pleased me still more than all this. Mr Charles Leaf, an old schoolfellow,

who bought my first picture, called a fortnight ago, and asked me to send him the prices next day, and said that he would have something, and spoke in the kindest way of me, so that my week has closed brightly. . . .

"I do not understand the scruples people have about taking the Sacrament. It is Christ's own command—'Do this in remembrance of me.' Surely if we keep up remembrances of our earthly friends, we cannot neglect His almost dying command, if we love Him, and are at all thankful for all He has suffered for us; and it seems to me that all who feel their own weakness, should come to receive assistance to do God's will. The Sacrament is not a reward or seal for those who think they have lived faultlessly, or who fancy that they are good enough to approach to God; but it is *a means of grace* for strengthening those who feel that they are unworthy sinners, and that they want help; who are sorry for the past, and feel that they cannot even repent without God's help through Christ. The strengthening and refreshing of our souls is promised to those who partake of Christ's body and blood, with a sincere desire to be enabled to repent of the past and do better for the future. In not attending, either we must feel we want no help, or we reject the way in which Christ offers to strengthen us. We do not find Jesus dissuade Peter, though He knew that the same night he would deny Him; because when Peter partook of it, he was sincere. I cannot help thinking that something of the Roman Catholic idea of the necessity of previous absolution and cleansing from sin before approaching the altar, is at the bottom of the reluctance, and a sort of idea that we ought to make ourselves fit and proper to approach to God.

"Does not David say, 'Who can tell how oft he offendeth? O cleanse thou me from my secret faults.'* The consciousness of sin is a gift of God's Spirit to be prayed for, and as we grow in grace, we shall see our sins more and more evidently. The heart of man is 'deceitful above all things, and desperately wicked,' and so, if not only the devil but our own hearts are trying to deceive us, no wonder we cannot see our own sinfulness, and must pray to God to shew them and their guilt to us. Many days may pass with no gross outward act; but are there no shortcomings? Nothing left undone which we might have done? No carelessness or forgetfulness of God's mercy and goodness? In fact, through the day, have we acted as God's stewards, and as if our bodies were the temples of the Holy Spirit? Surely, compared with Christ's perfect example of living for others' good, and not doing His own will, the purest and best men on earth must confess themselves sinners. I see Mrs Herschell speaks of the difficulty of fixing on any actual sin often. No human creature ever knows one tithe of the sins he has committed, but God will pardon our secret faults for Christ's sake, if we acknowledge that we are vile, and pray to be shewn our duty. . . .

" *Assurance* God vouchsafes to very few. It may be the fit reward of long and patient continuance in well-doing. What should we think if the sailor were to feel disheartened, because he was not sure when he started that he should arrive safely? Christ has said, 'My grace is sufficient for thee,' and, 'My strength is perfected in your weakness,' and 'Those who come unto me, I will in no wise cast out.'" . . .

* Psalm xix. 12, Prayer-Book Version.

"BERNERS STREET, *May* 3, 1855.

"Are you learned in dreams and the interpretations thereof? I have twice, within the last three weeks, dreamt that I was going to be hanged, and I was very seriously uncomfortable. The first time, I had the horror of attending the condemned sermon, which was preached by an old gentleman who could not be heard, and a lot of boys were jeering me, and would not let me hear the prayers. The last time, I began where the last left off, but they did not finish hanging me. Now this is a very serious thing—to dream twice exactly the same thing. My only hope is—as I have a dim remembrance of being told—that in dreaming, hanging betokens and is an emblem of matrimony. Is it so? Do tell me all you know about it. . . .

"I am not surprised to hear of Miss M——'s criticism on my Jerusalem picture. To an English eye, it must appear so, but I really believe that there was no more atmosphere at the time; and I know in my style of painting it is the side likely to err on, and I shall try and shew in my work this summer here that I do not do so. I think H—— agrees not a little with Miss M——. I have read nothing lately. I walk and paint in the mornings, have my time cut up into bits in the afternoon, and write letters, or go out, or go home in the evenings, and altogether feel rather in a whirl. I have picked up a few very nice books in my rambles in London, which we will discuss at leisure hereafter.

"The Academy opens on Monday; not a remarkable Exhibition, I believe. The hangers were of the old school, and they have kicked out everything tainted with Pre-Raphaelism. My Pyramids, and a head in chalk of Hunt's, and all our friends, are stuck out of sight, or rejected. Millais' picture was

put where it could not be seen; and he, being an Academician, made an immense revolution—persuaded Roberts and two or three others that they were badly hung, and carried his point by threatening to take away his picture, and resign at once, unless they re-hung him, which they did.* He told them his mind very freely, and said they were jealous of all rising men, and turned out or hung their pictures where they could not be seen. *Quant à moi*, privately, as I could not have expected that they would put me in a good place, it is much better that I have my pictures back in my own rooms, where people look at them, and like them. . . If I am to remain in the profession, my every effort must be directed this year to painting a striking and effective picture for next year, and in trying to avoid any peculiarities, such as those your friend criticises; for the attention of all those who have called on me this year, will be directed to anything I may exhibit next season. If I found then that I had not succeeded more with the public, I shall be exactly in the same position as I am now; and though, if I were alone, I should bide my time and work on, I should feel it wrong to risk the comfort of another, and should quit the profession, and re-enter the business, where they would be happy to have me, and where my father offers to resign in my favour. . . .

"To shew you how little we know what a day may bring forth: the very day I had your letter, last Monday, the Honourable Arthur Gordon came and said Mr G—— had commissioned him to purchase the small Dromedary, which I was obliged to say was sold, and offered to paint a duplicate, with an alteration in the man. I do not know if this

* It was hung at first some three feet above its ultimate position.

K

will be accepted. He then asked me if I would breakfast with him one day next week, and if I would let Lord Haddo see my pictures on his return from Egypt. Lear called this evening, and seemed to think that I had been successful enough to bear congratulation. I have seen two of my old Cairo friends this last week; one of them was Fletcher, whom you may recollect as an early chum. I was delighted to find he was not shot, for I thought he was at the Crimea."

<div align="right">

" 14 BERNERS STREET, OXFORD STREET,

Tuesday, May 14, 1855.

</div>

" MY DEAR E——,—To-day I have sold my water-colour drawing of a Shekh, which was unfinished when you saw it; and I have a commission for a copy of the Drome-dary, and a little larger one.

" Last night, I had a great soirée,—nearly twenty-five artists and literary men. My *confrères* congratulated me on doing so well the first year; but with to-day's catch I must myself allow that it is better than I deserved.

"The Exhibition is very generally commented on; they have either turned out, or hung where they cannot be seen, every one the most remotely connected with our set and our friends. I have quietly tried to rouse a disaffected spirit, or rather courage to do justice to ourselves, if others will not do it to us; and some dozen or fifteen men are to meet at my rooms next Monday, and consider whether we shall not set up an Exhibition of our own, which I think that there is every prospect of making a very prosperous thing,*

* This idea was not carried out. Such an Exhibition yet remains an object much to be desired.

for there are some who have a great deal of influence. Even the clever men in the Academy speak loudly of the injustice of the Hanging Committee this year.

"With all my interruptions, I have painted half a camel the last few days, and have great intentions for next year, which I will tell you about when I see you.

"After the number of people who have heard of or seen my pictures this year, next year will be a turning-point of my life in all probability; and we must not let the tide leave us, but try and swim with the current. At least I shall do my best endeavour, and leave the result to the good God, who is so merciful and bountiful. I will try and get to the sea-side for sometime this summer. I have a rocky fore-ground to paint in my picture of Mount Zion, which I could do at the sea-side; and a large picture of Jerusalem, for which I want corn-fields and a hilly country. These also might be found near the sea. For the background of my camel picture, I shall want a fortnight in a flat, open country; I think the Essex plains, near the mouth of the Thames, would do.

"I have an intense relish for being idle occasionally; but take care you do not encourage me too much in lotus-eating. I have been reading one or two of Sir James Stephen's essays on 'Ecclesiastical Biography,' which you must some day see. One on Pope Hildebrand is very fine, and there are interesting papers on St Francis of Assissi, on Ignatius Loyola, the founder of the Jesuits, and on the Port-Royalists. To-day, I have had 'Martin Luther,' a true man, with all his human passions and feelings. Stern rebuker of oppression as he was, he had a very child's heart-love of nature. 'That little fellow,' he says, speaking of a bird going to

roost, 'has chosen his shelter, and is quietly rocking him-
self to sleep without a care for to-morrow's lodging, calmly
holding by his little twig, and leaving God to think for him.'
Verily he has good taste too, for Stephen says that he was an
ardent lover of painting. I hope to have a great treat this
autumn. Tennyson will probably publish a fresh volume
before midsummer, and, please God, I shall read them to
you in the evenings when we meet.

"I think if you want a quiet place, just outside Sebasto-
pol would be the thing. They say now that the floating-
batteries won't float with their guns on board, at least that
their port-holes will be so near the water's edge that they
can never work except in a dead calm, and our Turkish
Contingent officers find there is no Turkish Contingent. A
pretty piece of business, is it not? They say a company
offered to Government to take Sebastopol in three months for
a million—'no take, no pay'—but Government refused. It is
generally thought that Peto would take the contract even now.

"*Thursday.*—I have been cooling my heels at Bucking-
ham Palace for three or four hours, and am obliged to leave
the pictures there till to-morrow. However, if they have
not had time to look at them before then, I shall bring them
away, for I cannot lose any more time. Adieu!—
Yours, etc. "T. S."

"14 BERNERS STREET, *June* 2, 1855.

"DEAR M——,— Mr Young * was here the
other day, and spoke in strongest terms of the extreme and
extraordinary accuracy of my Jerusalem picture, not only
in details, but in general effect—the atmosphere and dis-

* Formerly the English consul at Jerusalem.

tance so utterly unlike the thick atmosphere of England.
He told me the time of year and time of day at which it
was painted, and said he was sure it could only be properly
appreciated by those who have long resided there. It was
Mr Beresford Hope who sent him. I leave my prison to-
morrow, with no small joy at breathing fresh air again. I
am astonished that those men who I thought would have
felt a particular interest in a spot so sacred, have never
taken the trouble to call, for they were written to by those
residing there, to say how true it was.

"After all written and said, I hear of most wonderful
mismanagement at the Horse Guards. Captain S—— has
been for three months under orders to sail, and ten days
ago they sent out his troops without him. He went down
and saw the Quartermaster-General, and asked who was sent
out in charge of them. He was told, 'A field-officer.' He
said, 'That is impossible, for not one is in England.' 'Then
it is a captain.' 'That is impossible, for I am the only
captain here.' 'Then a subaltern.' 'I don't think so, for
I don't think one is gone.' Then the Quartermaster-General
said he knew nothing at all about it; and three days after,
Captain S—— was told that it was so small a detachment
that only a non-commissioned officer went. Three days ago,
he received notice from the Colonel to embark, and went to
the Horse Guards to ascertain what men he was to go with.
They didn't know. The next day he was told 'A detach-
ment.' Yesterday he embarked, and found on board him-
self, a cornet, and two men—just two men, and two officers
to take care of them, with his own men gone ten days
before with no one to look after them, and the Horse Guards
knowing nothing about it! Verily, we must alter."

CHAPTER IX.

SECOND EASTERN JOURNEY, AND DEATH.

ON the 3d of June 1855, Mr Seddon closed his exhibition, having, in the judgment of his artist and other friends, established a reputation beyond what could have been anticipated. His works had been favourably criticised in almost all the leading literary and daily journals; and those persons who were acquainted with the East, and who had seen his paintings, had testified to their wonderful truth and accuracy. As the fruits of the exhibition, he had sold several of the smaller pictures, and received commissions for others of importance; so that he felt that time only was required to enable him to succeed in his profession. Under these circumstances, he determined not to delay his marriage; and after making the requisite preparations, he set out for France, and on the 30th of June, at the British Ambassador's Chapel at Paris, he was united to the lady to whom he had been engaged during his residence at Dinan. After remaining a short time in France, he returned with his wife to England. During their stay in England they resided at Kentish Town, with the exception of the time occupied by short excursions into Derbyshire and the Isle of Wight in the autumn.

He commenced a large oil picture of "Arabs at Prayer in the Desert," and, during the winter, completed several of his unfinished studies, to be in readiness for the next season. He also made several drawings, to be engraved as illustrations to books, principally of biblical and sacred subjects.

The ensuing season (1856) he again privately exhibited his works in Conduit Street, and sent some pictures to the Royal Academy. These attracted considerable attention, and again the principal journals spoke of them in the highest terms. He was not, however, so successful as the former year, but received a commission for a picture of Arab life, from W. Marshall, Esq., of Preston, which he executed in the course of the summer.

On considering his plans for the future, and consulting with his friends, he came to the determination again to visit the East. With the experience he had already gained, he hoped to be able to do far more than on the previous occasion, and having obtained some reputation by his Eastern pictures, it seemed wise to follow out the same line; his own feelings also irresistibly inclined him to the choice of sacred subjects, which could only be truly and naturally painted where the incidents actually occurred. To carry out this plan would require him to leave behind him his wife and infant daughter, who had been born on the 30th April. This was a bitter trial, but as all his friends concurred in the opinion that it was the right step, it was agreed that they should return to Dinan, which, as on the former occasion, he would make his point of departure for Egypt. The following letter, written to his wife, who preceded him to France, refers to their approaching separation :—

"FRANT, *July* 19, 1856.

"MY DEAR WIFE,—I hope and trust that you got over safely without suffering. I woke at four o'clock, and the night was so still and calm that I thanked God for it. I was waiting at Farnborough, on a little bridge in a pretty lane, about the time you would be landing, and thought of the pleasure with which you would leave the close cabin, and to-day I have been thinking of your resting quietly after it all. . . . Our trials seem hard to bear, but how light they really are, and below the average! At Ash, a battery of artillery was waiting to go to Woolwich, *en route* next week for the Cape. Four soldiers' wives, with two children, and a big grown-up girl of thirteen, were crammed into our carriage, to fill up three seats, and I had to resist, by main force, the efforts of an old Irish woman, with five bundles done up in pocket-handkerchiefs of various degrees of anti-quity, who insisted on coming in too; for 'why should she be left behind? hadn't she paid her money?' Poor things! the orders had arrived only last night at eight o'clock, and next week they are to go on board, with infants and children, and their family goods in old cloths and handkerchiefs; no little bags full of every convenience, and no stewardess to assist them. Thank God, we are spared so much, and we may wonder why our lot should be so much brighter.

"The railway from Farnborough went through a most beautiful country—by Guildford, Dorking, and Boxhill. While I was at Farnborough on the bridge sketching, a respectably-dressed man came up and touched his hat. After standing a minute or two, he said, 'So you are doing something in my line, sir?' 'What!' said I, 'are you an artist?' 'Well, sir, I cannot venture to call myself an

artist, but I gets my living by making drawings. I makes 'em in pencil.' I asked him if he took portraits. 'I does every line, portraits and all; but I don't get many portraits since the daguerreotype came in. No, sir, my drawings are principally in the sporting line. I does portraits of gentlemen going over a fence, or a five-barred gate. I does 'em all in pencil, and puts a little colour on their faces, but all the rest in pencil—d'you see.' 'Yes; but do you make a good living?' 'Well, not much of that; I used to earn a good deal more money when I did portraits at sixpence each than I do now.' I said, 'I suppose you begin to see that you can do better, and it takes you longer.' 'That's just it; you've hit it, sir. I used to knock them off in a quarter or half an hour, and now it takes me seven or eight days to do a sporting piece.' So I told the poor man that I would willingly give him advice, but I was afraid it would ruin him completely, for that afterwards he would have to take two or three months. 'Yes, sir, I sees that; but I am too old now to learn a new line. But I find trees very hard; I can't manage them.' So I sat down, and drew a branch of a tree, which he said was very much in his style; and I gave him some advice which I thought might help him, and the good man went away so much obliged.

"Passing through the beautiful country, I thought of the future, and that, if it pleased God to spare us, we might perhaps find a cottage there; for the country would suit me beautifully, and it is easily got at from London.

"While I was waiting at Reigate, I saw this advertisement on the station-walls—'Lost, a *ridicule* basket, containing a parchment discharge and a pensioner's instructions; a character, and four baptismal certificates; a marriage certifi-

cate ; and other small articles. If found, to be forwarded to
the Seven Stars, Canterbury.' Here is an end of to-day's
adventures. That God may bless you, and bring us safely
to eternal rest, is the earnest prayer of

" THOMAS SEDDON."

He followed his wife to France in the beginning of August,
and remained quietly at St Enogat, near Dinan, until the
beginning of October, painting some small pictures. The
following extract refers to this time, and also to the picture
for which he had received the commission in the spring, and
which had been finished and sent to the owner just before
he left England :—

" ST ENOGAT, NEAR ST MALO, *August* 20, 1856.

" This is a beautiful place ; the coast is a succession of
little rocky bays, with fine jagged promontories and single
rocks standing in the sea, among which the waves boil and
bellow gloriously ; while at the middle of each bay is a
beautiful sandy beach, stretching out half a mile at low
water, and you know how picturesque the innumerable
rocky islands in front of St Malo are. I have had a very
satisfactory letter from Mr Marshall about his picture. He
says, ' I assure you that I was more than pleased. I
shewed it to Frith and Egg, who showered praises on it.
Frith said, " Two years ago, I hung one of his pictures in
the Academy ; but there is great improvement here. Egg,
come and look at this picture !" And they studied it
over and over again. I am sure that they examined it for
ten minutes. I put in a word, and Frith said, " Oh, there
is merit here, which no one but an artist can appreciate."

He particularly pointed out the shadow.' He has spoken
to a friend of his, who has influence, about hanging my
pictures, and he has promised to give them good places ;
and finding that there was a rule limiting each artist to
two, he very kindly withdrew his. He says that he hopes
his brother-in-law will take one of my pictures, as he is
much pleased with his."

In the beginning of October, having finished the few
things he had undertaken at St Enogat, he prepared to
start at once on his last journey to the East. In what a
spirit of hopefulness, tempered with Christian resignation
to whatever God might allot, he went on his way, will be
best seen from the following extracts from letters, which
now seem almost written as if in expectation of the event
so soon to follow. The first was addressed to his wife :—

" PARIS, *October* 12, 1856.
. . . . " I got to the hotel at six ; and after taking a
turn, and looking at the Marseilles Railway-table, I re-
turned and read the service, and prayed for you and baby
before going to bed. In the railway, I intended to
sleep half an hour, but slept two hours ; and then I tried
to repeat the service from memory; but you know how bad
mine is. However, I thought of all God's mercies to me and
mine, and prayed for His blessing and guidance for us all.
Dear sweet baby ! I take the dear innocent's happy mirth
at parting for a good omen. I am to sail in the *Hydaspes*,
one of their finest new boats." . . .

To his Aunt :—

" MARSEILLES, *October* 15, 1856.

. . . . " I left my dear wife at five o'clock last Monday morning; so necessarily we were too busy in getting ready to give way to sorrow. She has borne the whole bravely, not adding pain to a painful duty by useless laments. My dear baby crowed and laughed merrily as I kissed her with a full heart. I was well pleased to see the little innocent so happy in her ignorance. Indeed, all smiles on me. I have nothing but kindness and affection from relatives and friends; my dear, dear father, first and most of all. May God reward him a thousandfold for his affectionate kindness to us all! that he may find the deep truth of 'whom the Lord loveth, he chasteneth,' and that all his present trials may even here below become blessings, is my fervent prayer. But, indeed, to every one, and you not least, I am most deeply grateful for all your love and kindness. God bless you all, and grant that we may meet again in happiness. I have had very kind letters from Hunt and Brown, full of kind advice and encouragement, and I go full of hope that God will bless my exertions."

" *Eight o'clock*, ON BOARD THE HYDASPES,
October 17, 1856.

" MY DEAR WIFE,—. . . The day that we started was splendid, but there was a strong north wind. The great long waves in the open sea were much less *gênant* than the short chopping ones nearer shore. I slept well all night, and in the morning the wind had fallen, and we were breakfasting in the Straits of Bonifacio. No one has been ill all day, and the sea is calm; we have been going ten knots an hour, with a slight head-wind, and I am suffi-

ciently easy to write to you, and feeling every day how much suffering I am spared that others undergo. I have a cabin with four beds, tenanted by a brother artist named Huguet, going to Cairo for the second time, apparently a very nice fellow; a quiet little servant to one of the first-class passengers; and myself. The Bishop of Jerusalem and his two daughters are on board, and we are very good friends. At dinner, I sit next to a *bon père*, who is schoolmaster at Saida, the ancient Sidon; and next to him is another, who belongs to a convent near Beyrout. There are also on board the Princesse de la Tour d'Auvergne and six nuns, who are going to found an establishment at Nazareth; three or four people going to Egypt for their health, of whom I will speak more to-morrow, for the shaking of the screw makes my head ache in writing. So good-night, my own love, and my own darling child. God bless you both!"

"VICTORIA HOTEL, ALEXANDRIA, *October* 24.

"MY DEAR WIFE,—No post till to-morrow week; still I will begin and tell you about my adventures. Thank God, I am all right, after a most disagreeable passage, with wind, rain, and rolling sea ever since I wrote those few lines. It was utter discomfort: no one could read or write, or even stand, on some days, and a great deal of rain fell, so that the deck was swimming; so I used to lie down, thinking of you and my dear babe at home, and of all God's goodness to you and me; others were suffering really severely, while I only felt inconvenience. We did not land at Malta till one o'clock on Sunday, and left again at five; however, I secured a good dinner, for the *cuisine* on board was detestable, and the cabin, from being close shut all day and night,

was enough to make one ill. On the whole, the *garçons* were very attentive, though I was rather angry when, having asked for some *bouillon* at one o'clock on Tuesday, they told me that the *marmite* had just upset, and the cook had fallen into it, and scalded his leg ; and the next day they forgot my tea at breakfast, and told me they could not make it, for the *marmite* had again upset, and the cook scalded his other leg. I recommended them to get cooks with four legs, and then they could afford a leg a-day. . . .

" While I was at the consul's, who should come in but Mr Bruce, who asked me to dine with him. Huguet is here with me; he will come into the country with me if I go, so that you see I shall not be quite alone. On board, I also fell in with Mr Green, whom I met when last in Cairo; he seems to be in very bad health, and is going up the Nile. At six, Mr Bruce called for me in his carriage, and took me out to his house. I found there a Captain Mansel, who is in command of the *Tartarus*, which is on the coast surveying ; the consul and his son ; and a French Count, who is a cavalry colonel. Mr Bruce talked over my plans with me, and offered to introduce me to the Governor at Cairo, who, he said, would give me every facility in case I should wish to paint from the citadel ; and he has given me a letter of introduction to Hakekyan Bey, who speaks English well, and may be of use, and he has commended me to his head-interpreter at Cairo, old Masarra."

" *Monday Evening*, CAIRO.

" Here I am at last. I came up by railway, leaving Alexandria at 9 A.M. Such a scene of confusion ! I got there before half-past eight, and found a crowd round the ticket-

place, where one old Italian was dealing out the tickets. He took a quarter of an hour to give change to one man before me, stopping half-a-dozen times to count the piastres over and over again, for fear of a mistake. Fortunately for me, in Egypt there is great respect of persons; so I got my ticket before fifty natives and worse-dressed Europeans, who were all waiting long before me. As to the natives, three-fourths of them were left behind, because the Pasha chose to send up a squadron of body-guards by rail to Cairo. Well, I went for my luggage, but was told that I could only take with me my portmanteau, and that my two picture-cases must be registered as articles of *messagerie;* so they were taken to a counter, behind which was a Frank clerk writing. I told him that I wanted to go by the train. He said that as soon as he had done his business he would attend to me. I waited patiently some time, and then expostulated. He said that he must finish what he was about first, and then, if there was time, my luggage should be done. I begged and prayed him to do it at once, when off he went. The first bell rang, and I jumped over the counter, and found my man weighing bales of cotton, at which I was furious, when a gentlemanly-looking man came up and said, 'Come with me, you have only just time to get off.' I shewed him the boxes, and he got hold of the clerk to make him do them. Just then I saw the director, Mr ——, whom I know, and shook hands with him, and he said that he would see that they were sent on to the hotel next day. I was hurried off, and thrust into a first-class place, which had been reserved for one of the officials, who was stuck outside—and off we went, through a country as flat as a table, to Cairo, to the immense disappointment

of several passengers with tickets, for whom, thanks to the Pasha's cavalry, there was no room. Good fortune again attended me, for I sat next to Mr Stanton, an engineer, who is superintending the railway from Tantah to Semennood, a branch line; and as the only Englishmen there, after half-an-hour's silence, we began to talk. I found that he had come to Jerusalem fifteen days after I left, and had heard of me from Hunt and Lear, and knew several men whom I knew; so I got much information from him, and a letter to Omar Effendi (the head of the station at Kafr es-Zayt, where we were ferried across the Nile), asking him to give me the keys of the house belonging to the engineers there; and as there are some very beautiful villages there on the Nile, I shall probably avail myself of the opportunity. Is it not wonderful what great mercies and facilities I find in my daily path? for I have several other most promising offers which I must tell you to-morrow, for it is nearly ten, and I got up at half-past five, and have been about all day. Good night. God bless you, and all your good kind family; surely goodness and mercy follow us all the days of our lives.

"27th.—Things crowd on so fast that I seem writing nothing but a journal of my doings, and not of my feelings. Never fear, you are never out of my thoughts; and in all I do, the tedium of separation from you and our child is cheered by the hope that God will bless the task, and enable us to live in greater comfort, or, at least, in honest independence. Indeed, thank God, our three lives are bound together by dear ties which death itself cannot sever—love to God, I hope and trust and pray, ruling and sanctifying and blessing all. Yet I cannot afford to dwell too much on my

feelings, for I am obliged to set to work, to steady serious thought about the subjects of my pictures; for all depends upon that. . . .

"At present, I am in a whirl all day, seeing and looking at this living kaleidoscope, searching for subjects, and I am scarcely collected enough to think, but in a day or two I shall begin something *pour boucher les trous.*

"Huguet introduced me yesterday to Weliki Bey, a young Egyptian, educated at Paris, who has a farm and a large country-house near Ghizeh. He asks us to go and stay there whenever we like, and we shall have camels and cattle and Fellahin to paint from as much as we wish. A great deal of the country is under water now, and it is extremely beautiful, with the reflections of the trees in it. I want to begin some small thing at once near here. Ah! had I been hard-hearted, and left a month earlier, it would have been so much better. Alas! the dates are all picked, and the pilgrims from Mecca have all returned, and there are only a few straggling Mecca men left. I have been out for five hours to-day upon a donkey after their scattered tents, sketching some picturesque dromedary saddles and gear, and to my delight I find that I can talk tolerably.

"Mr Williams introduced me yesterday to Dr Abbott, a very old resident here, who puts his house and courtyard at my disposal to paint in, and has invited me to his Wednesday evening receptions.

"My boxes with the pictures have arrived safely to-day, so that the only thing that detains me, is writing all the evening to you, which prevents my putting my painting things in order; then I have been lent Lane's large edition of 'The Arabian Nights,' which I want to study for man-

ners, &c. Is it wet and cold with you? Here it is fine
and clear, with wind; 70 to 75 degrees in the shade, and
beautiful floating clouds preventing the sun from being too
hot—all wet left behind at Alexandria. The earthquake
has knocked down some houses, and split most of the others
more or less. On Thursday, there is to be a grand cere-
mony of the entrance of the *Mahhmil,* or sacred carpet,
from Mecca, which you must hear of in the next letter. So
good-night. From your affectionate husband,

"THOMAS SEDDON."

"CAIRO, *October* 30, 1856.

"MY DEAR WIFE,—. A week is past since I
landed in Egypt ; it seems a month, not from weariness, for
I have been too busy to have let time hang heavily, but
from my having seen and done so much. At present, I shall
go to Old Cairo, three miles off, to an hotel opened by an
Italian on the banks of the Nile, in a beautiful position,
just opposite Rhoda Island, where there are some lovely
views. There is a ferry-boat twenty yards from the house,
where I can cross at any time.

"I have begun a water-colour painting of a water-carrier,
with his earthen jar upon his shoulder, with a curious brass
top. I think I have got it very powerful. I worked five
hours yesterday and the same to-day upon it.

"Last Thursday, I went with Mr Preston, who is staying
here, at six o'clock, to see the Mahhmil, or sacred carpet, come
in procession into the town. We found three or four regi-
ments of cavalry, and a crowd of Bedouin playing with the
djereed, until it was time to begin. They drew up in two
masses, 500 yards apart. One man galloped forward with

a thick palm-stick (djereed), and darted it at the others when he got near, and then wheeled round, and galloped back, pursued by two or three others, who, in their turn, threw their djereeds, and whirled back. There was a regiment of irregulars dressed in every variety of old finery, regular Bashi-Bazooks. While this went on, the canopy of the Mahhmil, a sort of pagoda of crimson velvet embroidered with gold, was put upon the camel, which was covered with housings to match, and at eight o'clock the procession formed—cavalry at the head, then forty or fifty officers in grand half-European costume, with caps a yard high, except the colonel of a regiment, who had a cap of black velvet, with a turban of cloth of gold, and a scarlet pelisse with gold frogs in front, and a grand scimitar-shaped nose— he was glorious! The sacred camel was surrounded by Arabs mostly from Mecca, gaily dressed, and followed by eight or nine camels. On the first of these was a man with long hair, stripped to the waist, who rolled his head from side to side; then a Shekh or two; and, lastly, men beating kettle-drums. We saw them go into the city gate, and then we rode round by a short cut to the Roumaleeyah, and saw them come in there. Oh! an Arab crowd is very different from an English one: the white turbans and gay dresses make the place look like a flower garden; but, alas! the palmy days of Mohammedanism are past. There was a wonderful absence of enthusiasm; and in this, the most sacred festival of the year, the place was not half full of people.

" We then came home to breakfast, and Dr Abbott's servant came to shew me a small house in a garden. The garden has some beautiful pictures in it, and would be very desirable, but it is held at present by some American mis-

sionaries, who cannot decide for a few days whether they can let me have it or not.

"OLD CAIRO, *November* 3, 1856.

"MY DEAR HUNT,—You will know by a scrap I sent in a letter, that I have got safely here. In this second visit, though the zest of novelty is gone, yet all strikes me with deeper interest than before; and I find, I think, the full benefit of a year and a half's digestion in a deeper and calmer analysis than before. I find that my impressions of atmospheric effects had lost the wonderful delicacy, and glory of colour at the same time, of the reality. The greater amount of vapour in the air at this time of year gives skies and distances of the utmost softness, while half-an-hour after sunset, the black, black outline of the trees stood against a sky of flame below, going into the most tender violet, and a little to the south, the white shining light of the moon glittered on a full-toned violet sky.

"I have come to-day to a house opened at Old Cairo, about three minutes' walk on this side of the ferry over to Ghizeh, so that, looking down the river, one sees the end of Rhoda Island, with a glorious tuft of palm-trees. From the front you see the Mokatlem hills, and the broken ground between, which is glorious with the afternoon's sun. Should you ever come again, try and come in September, to see the inundation. Even now there is enough water out to give great beauty to the landscape.

"I am expecting my painting traps in three or four days from London. As soon as they arrive, I shall begin a subject of Fellah life, about two feet six inches by two feet. I have begun a water-colour sketch of a Khem'alee, or

water-carrier, with a fine head and curious brass-headed water jar.

"I write to you by this mail, to tell you that, after being to all the silk and cotton markets, I cannot see what you want; my only idea is to have a caftan made as a pattern, and for you to have it copied in England. I do not know whether you remember the mania the Cairo people have for dull arrangements of colour.

"I have an offer of one of the finest dromedaries in Cairo to paint, which I intend to do, of a largish size, in the desert; but I must study for a good subject. I was very sorry indeed to hear of your father's serious illness, and the consequent weight of anxiety thrown on you. However, I believe this world is not intended to be a holiday, and the more serious work and thought a man has to do, the more useful and beneficial will he be both to others and himself. Good steel must be well hammered by the shocks of doom. Remember me kindly to all friends; and believe me yours very sincerely,

"THOMAS SEDDON."

"11th November.

"MY DEAR WIFE,—God bless you for your kind letter. If you only knew how opportunely it came, and how, in spite of the sad news, it cheered me. . . . I wish I could at once come forward and do what you propose; but do you remember copying out a passage from Carlyle respecting conflicting duties? When several duties press, and you cannot tell which to select, do the duty nearest to you, the most immediate and clear. There is one, at any rate; and then see if you can begin with No. 2 without neglect-

ing No. 1. Many persons seem to me to spend half their
time in arranging for trials and troubles that they *foresee*
that God is going to send them; whereas the Bible says,
' Enough for the day is the evil thereof.' " . . .

" HOTEL, BEL LEON, OLD CAIRO.

" God moves in a mysterious way, to shew us that not
of our wills but of His we live and move. I have had a
little attack of diarrhœa consequent on the bad passage
and sudden change of living. On Monday week, the 10th,
I came down to this hotel, and from having had this
hanging about since my arrival, and my really not knowing
what was going on, the next day it began. I sent to Dr
Abbott, who sent medicines and directions, and in three
days told me that all bad symptoms were gone, and that I
wanted diet, not doctor. The man of the house has tended
me as carefully as if I had been his own son.

" *Friday.*—I am writing lying on a sofa facing the river,
feeling calm, quiet, and quite comfortable, except from weak-
ness and from innumerable flies and mosquitoes. For four
or five days, during which I took laudanum and opium
pills, I was too whirligig-headed to write; but now, thank
God, I believe that all I want is patience to lie still a few
days longer, till nature works round. On the opposite sofa
is a very nice fellow, an Indian officer, who cannot stand,
from the united effects of rheumatism and fever. We hit
it off well, and pass the time in pleasant chat.

" This is a sharp curb, just as I felt ready to set to at my
work; but God has humbled me, and I trust proved me, and
I believe punished me for a want of sufficient attention to His
Sabbath; for if, instead of walking about all day before and

after church, I had spent both Sundays quietly at home, I might have been spared this. Humanly speaking, I cannot charge myself with want of caution. Between myself and God I was thinking I will do this and that, and my gracious God said quietly, ' If I choose;' and, thank God, I hope I humbly say, 'Thy will be done, O Lord; as Thou wilt, and not as I will.' On board, and the first day, when I did not know what would turn up, I prayed for health; but I felt happier to trust you, and all, and myself, to Him who is a tender father. Now, thank Him, each morning finds me better than the last; but all beg me not to be in a hurry, but to keep very still for some days. My ink is as thick as mud, so that I cannot write well. . . . Give my kind love to all, and praying that God may support and keep you and my child, believe me your most affectionate husband,

"THOMAS SEDDON."

The concluding portion of the last letter was written with so trembling and uncertain a hand as to cause considerable anxiety lest his attack should be in reality more serious than either he anticipated or wished it to be thought ; and the knowledge that his weakened constitution could ill sustain the enfeebling effects of the insidious malady with which he had been seized, contributed greatly to alarm his friends. They were not, however, long kept in suspense, for closely following the receipt of the above letter, came the melancholy intelligence from his friend, the Hon. Mr Bruce, the Consul-General, that all was over.

It appears that on his arrival in Egypt, those that had known him during his previous residence there remarked how much paler and thinner he appeared. There can be no

doubt that he had suffered fearfully during the voyage, from the unwholesome diet and want of comfort in the vessel, combined with the boisterous weather; and perhaps he exerted himself too much immediately after his arrival. He was missed from his accustomed place in church on the Sunday after he had removed to Old Cairo; and the Rev. Mr Lieder, the Church of England missionary, hearing that he had been ill, rode down after service to see him. He found him in a state of extreme prostration, the result of dysentery, and the next day, November the 17th, he most kindly removed him to his own house, and nothing could exceed the care and attention he received there from Mrs Lieder and her friend Miss Daniell, who resided with them. The remedies of Dr Abbott, who continued to attend him, appeared to have overcome the disorder, but though everything was done that medical skill or Christian kindness could devise, his strength rapidly gave way. The manner in which he was then repaid, by the hands of strangers, for all the devotedness with which he had himself watched by the dying bed of Mr Nicholson, in circumstances similar to those in which he was now placed, is too remarkable to be passed without notice. He seemed to be quite unconscious of his danger, and spoke hopefully of the future, yet expressing entire resignation to God's will. He was throughout calm and devotional, trusting fully in the atoning blood of his Redeemer; he was often engaged in silent prayer, and spoke frequently of the importance of hallowing the Sabbath, and of the barrier it presents to the influx of worldliness. Once he remarked, "When I recover I will have no compromise between religion and the world: I will, with the Lord's help, be *wholly* on the Saviour's side."

Those around him were so satisfied with his frame of mind, that as long as there was any hope of his recovery they forbore alluding to the probability of a fatal termination to his disorder, lest in his enfeebled state it might prove hurtful; and when, on Thursday the 20th, it became sadly apparent that his hours were numbered, he sank into unconsciousness, and remained in that state until he gently expired at 3 A.M. on Sunday, November the 23d.

He was buried with all due solemnity in the same small cemetery whither he had, two years before, followed the remains of Mr Nicholson, and which he has touchingly described in a letter written at that time. A marble slab, with a simple, plain cross standing thereon, bearing the following inscription at its foot: " To me to live is Christ, and to die is gain," will mark the spot where his remains rest. On the slab is engraved—

THOMAS SEDDON, ARTIST,
WHO DIED AT CAIRO, THE 23D OF NOVEMBER, 1856,
AGED 35.

To which is added a verse from one of his favourite hymns—

" Thou art gone to the grave, but we will not deplore thee,
 Whose God was thy ransom, thy guardian, thy guide;
He gave thee, He took thee, and He will restore thee,
 And death has no sting, for the Saviour hath died."*

The surprise and sorrow which the tidings of his death awakened throughout the whole circle of his friends and

* His family have since learned with unfeigned pleasure, that before this memorial had arrived in Egypt, a marble headstone bearing his name, with the words, " Erected by a friend," already marked his grave. In gratitude for this kindness from an unknown friend, they cannot but desire that this headstone may remain in connexion with the slab that has been sent over by his widow.

acquaintance cannot easily be described. His buoyant spirits and sparkling wit, but, in a still greater degree, his unselfish and affectionate nature, had rendered him the life and soul of the society in which he moved. The reputation he had already won gave such promise for the future that much fruit had been expected from this second Eastern journey ; and he had so recently left in cheerful spirits and good hope, that this sudden and unlooked-for termination to his labours and his life cast quite a gloom over those that knew him.

His friends had, indeed, the unspeakable consolation of feeling that in his case they need not sorrow as those who have no hope ; for his conduct for some time past had been so practical an exemplification of Christianity—he had been, without obtrusiveness, so zealous for the cause of Christ, seeking to lead those around him to appreciate, as he had learned to do, the beauty and the blessedness of religion, that they could not but feel assured that to him the change was a happy one. They recalled how peculiarly of late he had dwelt on passages bearing on the shortness and uncertainty of life, and how he had remarked, on more than one occasion, that he neither expected nor desired to be long-lived ; so that it really seemed as if he had felt a presentiment of his death, and was studiously making preparation for it.

A short time after the melancholy news had arrived in England, some of his artist friends met together at the house of Ford Madox Brown, Esq., for the purpose of considering what steps they could take to testify their respect for his memory, and their admiration of his works, which they felt deserved some public notice. They afterwards in-

vited the co-operation of other gentlemen, who had been acquainted with him and appreciated his efforts, and convened a meeting at the house of W. Holman Hunt, Esq., which was numerously attended. Professor Donaldson, John Ruskin, Esq., and others, addressed those present, the latter remarking, " that the position which Mr Seddon occupied as an artist appears to deserve some public recognition quite other than could be generally granted to genius, however great, which had been occupied only in previously beaten paths. Mr Seddon's works are the first which represent a truly historic landscape art ; that is to say, they are the first landscapes uniting perfect artistical skill with topographical accuracy ; being directed, with stern self-restraint, to no other purpose than that of giving to persons who cannot travel, trustworthy knowledge of the scenes which ought to be most interesting to them. Whatever degrees of truth may have been attained or attempted by previous artists have been more or less subordinate to pictorial or dramatic effect. In Mr Seddon's works, the primal object is to place the spectator, as far as art can do, in the scene represented, and to give him the perfect sensation of its reality, wholly unmodified by the artist's execution."

At this meeting a committee was formed, and Mr W. M. Rossetti appointed honorary secretary, " for the purpose of raising a subscription for the purchase of the oil picture of Jerusalem, painted by the late Mr Thomas Seddon, from his widow, for the sum of four hundred guineas, and to offer it to the National Gallery."

The efforts of the committee were most successful. The Society of Arts kindly lent their spacious rooms for the exhibition of his works, which were collected for the purpose,

and visited by a large number of persons. Mr Ruskin again came forward, and delivered a most able address on the subject at a conversazione held for the purpose, and the result of these generous efforts was, that a sum of nearly £600 was raised by public subscription. With this the committee purchased his picture of Jerusalem, as they had proposed, and offered it to the trustees of the National Gallery, by whom it was accepted, and it is now placed in Marlborough House. The balance of the subscription, after paying the contingent expenses, was presented to Mrs Thomas Seddon, as a testimonial of the recognition by the public of the merits of her husband.

Nothing could have been so gratifying, or so calculated to comfort in their hour of sorrow those who loved him ; for it had been one of the dearest wishes of his heart that this picture should ultimately be placed in the National Gallery. He had offered it to a gentleman, who expressed a wish to purchase it, for a lower sum than he would otherwise have taken, on the condition that he would promise to leave it to the nation at his decease ; and the Editor has in his possession a memorandum, in his handwriting, of a plan which he proposed of painting a large copy of it, and presenting it to some public institution, for the purpose of acquainting people with a spot fraught with such undying interest, and in order to give them a correct representation of the very places which were so often trod by our Redeemer during His sojourn on earth.

In bringing to a conclusion these brief memorials, the Editor cannot refrain from thanking from his heart those who thus generously stepped forward, at great personal sacrifice, to rescue from oblivion the memory and works of one

so dear to him; and he trusts that he may have been able to gratify them in some degree, by the particulars he has endeavoured to collect respecting him in whom they have shewn so warm and deep an interest. In any case, theirs is the satisfaction of feeling that they have decided rightly the question, so eloquently put by Mr Ruskin at the Society of Arts,—" Whether they would further the noble cause of truth in art, while they gave honour to a good and a great man, and consolation to those who loved him; or whether they would add one more to the victories of oblivion, and suffer this picture, wrought in the stormy desert of Acel- dama, which was the last of his labours, to be also the type of their reward; whether they would suffer the thorn and the thistle to choke the seed that he had sown, and the sand of the desert to sweep over his forgotten grave."

REMINISCENCES

OF

EASTERN TRAVEL:

A Lecture

DELIVERED AT CARDIFF AND AT HIGHGATE.

BY THE LATE

THOMAS SEDDON, JUN.

REMINISCENCES.

THE earnest practice of my profession leaves me no time for that serious study of a subject which can alone, in ordinary circumstances, entitle a man to be more than a listener and a learner. But, in truth, I shall only attempt to tell you simply what I saw and heard during a year's residence in the East, which I did not spend at hotels, or in passing rapidly through the country, catching transient and necessarily superficial views of men and things ; but, forced by the requirements of my profession (or at least by my conviction that truthfulness is its one essential corner-stone, without which all the adornments of light, and shade, and colour, are shams and delusions—that is to say, in pictures that profess to bring foreign lands before the eyes of those " who live at home at ease")—I lived in my tent, and stayed for several months at a time in one place, so as to have leisure to know the people well among whom I was thrown.

Travellers are very ready to give a bad character to the people, when really they may thank themselves for most of the annoyances they meet with. Some think, and shew they think, all Arabs thieves ; and as they repose no confidence, they are treated as fair game. Others allow too great familiarity at first, and find it end in insolence, or think that the mere rough play which they provoked or allowed at first is intended for such. But during a year

M

which I spent in an open tent at the Pyramids and at Jerusalem, nothing was ever stolen from me, and several things I had lost were brought back ; nor had I ever an unpleasant word with an Arab.

I sailed with a friend from Damietta in Egypt, in a native ship of fifty tons, bound for Jaffa ; she was an open boat, laden with rice, and we made ourselves very comfortable by rigging up a sail, tent-fashion, over the ship's boat, which was laid on the top of the cargo at the stern, while the forepart was occupied by two Turkish merchants and their servants from Jaffa, and five Indian Mussulmans, fellow-subjects of Queen Victoria, bound on a pilgrimage to the Holy City.

At daybreak on the third day we were a few miles from Jaffa, and, as the wind was westerly, we drifted rapidly towards the shore, and I saw that, by steering straight for Jaffa, we should soon be on the rocks. I spoke to the Reis, who, with a great deal of grumbling, ordered the men to get out the sweeps; but it was just the end of the Rhamazan, their great fast, and continuing from sunrise to sunset for a month without eating or drinking had worn out their temper and their strength, and they pulled so lazily that, at six o'clock, we were within a few hundred yards of a rock-bound coast. The only thing to do now was to run the boat in between the rocks, which, as the sea was very calm, we fortunately succeeded in doing; and there we lay all day, in very bad temper, till the land-wind sprung up in the evening. An hour's walk would have brought us to Jaffa, but we should have got the captain into great trouble by breaking the quarantine and police laws; and some suspicious-looking wild Arabs made it advisable not to stray far

from the shore. However, we walked to the top of one of
the sandhills which line the coast, and from there we had
a fine view. The sand stretched about a half or three-
quarters of a mile inland, becoming more thickly studded
with weeds, long grass, and bushes as it left the shore.
Beyond, the ground was covered with short bushes; and still
further on, brown undulating hills, like our heather-clad
English hills, stretched away to the blue mountains of the
hill country of Judah, which lay, half-veiled in morning
vapour, fifteen or sixteen miles away. To the left, was a
broad shallow valley, down which a stream flowed through
the sand, and between the ruins of a Roman bridge, to the
sea. Jaffa lay beyond, to the north, built on an isolated
rock standing on a slightly undulating plain.

Jaffa is a flourishing town, well built of stone, and with
a look of comfort when compared with Egypt, which seems
blighted by oppression and decay, and where the whole
country, and everything in it, is mud, quickly falling back
again into dust. Palm-trees are the colour of mud, buffa-
loes and camels are the colour of mud, and so are the men
likewise. Their houses are built of dried mud, and the
whole country is made literally of the mud of the Nile.
The wretched Fellahin, in Egypt, are miserable slaves; but
on landing in Jaffa their independent bearing shews at once
that the Syrian mountaineers are a very different race.
They are practically independent of the Sultan; and beyond
the town gates the Turkish Pashas have no real power.
Even the stern hand of Ibrahim Pasha could not keep them
from constant outbreaks; and the poorest half-naked Arab
throws his ragged abbayah grandly about him, and stalks
along with his sword in his belt as proudly as his chief.

Indeed, the Pashas, unless more than ordinarily energetic, are perfectly unable to protect any one outside the city walls; and the Silwanees, within a gun-shot of them, say he is only Pasha by day—at night he is no Pasha at all.

Meshullam, a Christian Jew, who has made a farm at Urtass, just below Solomon's Pools, nominally rents his land from the Sultan; but he has had to pay the villagers of Urtass £5 for every half acre he has enclosed, in order to remain undisturbed, which is good reason why this fertile valley lies waste. If he has had an animal or anything stolen, he never thinks of going to the Turkish authorities; for even when you have bribed the judge, you are not sure of justice if your adversary outbribes you; but he finds out with which tribe of the neighbouring Arabs the animal is, and he gets a dozen friends and rides off with them to the Shekh of the suspected tribe, and says he has some business to do with him. No Arab will begin business with a stranger at his own home without shewing him the usual hospitality, nor until he has slept there a night; so they all sleep with the Shekh. After breakfast the next day, the Shekh says, " Ya, Effendi, pray tell me what your business is;" on which Meshullam tells him that he has lost an ox worth 200 piasters, and that he suspects one of his tribe of having taken it. If the Shekh really knows the offender, he will often restore it at once; but if not, he pretends to be very much astonished, and denies it; but Meshullam persists, and says that he is able to prove it; that " truth is the image of friendship,"—and that he will come again with several more of his friends, if he does not give him the animal or the price. The Shekh now begins to fear that they

will eat him up, and Meshullam often returns with the price of the ox, which the Shekh has paid for fear of future invasions. Even if his tribe were not the real thieves, he generally knows who is, and gets the money back from him or his tribe in the same way.

The Bedouins of the Jordan are strong enough to beard the Pasha on his divan; and not long ago, on the appointment of a new Pasha, a large body of their Shekhs came up to Jerusalem in their state-dresses, and on their best horses, well armed with their long spears, to offer the usual salutations. While they were seated on the divan with coffee and pipes, and after no end of compliments, the Pasha delicately alluded to an arrear of 100,000 piasters due from them to the Sultan as tribute, and inquired when they could pay it. "Money is sweet balm," said the Bedouin, "but it does not grow in the desert." "Shall I have it next month, or next year?" asked the Pasha. "Oh! heaven will provide!" answered the Bedouin. There was a ceremonious leave-taking, but the money never came.

But with the petty neighbouring Shekhs, whom the Pasha has under his thumb, it is another matter. They may quarrel, and welcome, for then both come to him to decide and avenge them of their adversary, and bribes pour into both hands at once. Two Shekhs of little villages close to Bethany quarrelled, and were about to fight, when their friends persuaded them to make it up, saying that if any one was killed there would be blood-money to be paid, and that the Pasha would interfere, and that they both would have to pay him heavily. When the Pasha heard that they had made up their quarrel without coming to him, he seized them both, and kept them in prison until he had screwed

out of them as much as they would have paid him in bribes
and fines if they had gone on to fighting.

Ever since we restored the Turkish rule by taking away
Syria from Mohammed Ali, there has been no government
in the country. When the Pashas happen to be strong
enough, they make the Shekhs within their reach pay the
taxes, which consist of one piaster for every olive-tree, ewe, or
she-goat; 10 piasters for an ass; 20 piasters, horse or mule;
30 piasters, camel; 75 piasters, ox; 35 piasters for an acre
of fig or vineyard, and a kind of property and capitation
tax laid on each village, and raised by the inhabitants at so
much per head. But they fight and plunder each other as
they choose, though they are rather shy of injuring Euro-
peans, and especially Englishmen. Still, it would not be
wise to offer too great a temptation, as a poor German doc-
tor did, who went to botanise near the Dead Sea in a blue
coat with brass buttons, and who was, of course, shot for
the sake of his glittering buttons.

In Mohammed Ali's time, the traveller could go any-
where without escort, except near the Dead Sea and Jordan;
for Ibrahim Pasha made every Shekh responsible for all
outrages on his ground, and laid heavy fines on the near-
est villages, besides hanging two or three men, whenever a
murder was committed, so that whether the right man suf-
fered or not, somebody did. He cut roads through the
country for cannon to pass, and punished revolts without
pity. The men of Bethlehem, the most turbulent of all,
revolted in 1834; but he came upon them near the pools
of Solomon with his cavalry, and sabred 800, whose whited
skulls lie in a cave by Rachel's Sepulchre. He then banished
every Mussulman inhabitant from Bethlehem, pulled down

their houses, cut down their olive-trees, and drove off their cattle. A few sharp lessons of this kind quieted the whole country, and made them respect him very much. To this day, they say that Ibrahim was a great prince, and the only man who knew how to manage them. "When he said a thing, it was no play; if you did not do it at once, whish! off with your head!" But when they saw Ibrahim Pasha, who had beaten the Sultan and kept them in such order, driven out in two or three months, and Acre, which Bonaparte could not take, taken by the English in half-an-hour, it made a great impression on them, and they now think that we can do everything. There is no name so respected there as that of an Englishman, and so it will continue as long as we are the strongest; but if we had not taken Sebastopol, there would have been an end of our influence, and the Russians would have gained all that we had lost.

To shew you how great the prestige of our name is, an Englishman can travel in safety over the whole East; and in districts where a Turkish Pasha dare not venture with 500 horse, he will meet with welcome and respect. I cannot illustrate this better than by reading you an account of what happened last year at a village seven or eight miles from Jerusalem, from a letter I received from a friend who was then there :—"At Urtass we saw groups of people on the mountains, carrying large bundles of household stuffs, and we learned that these were Fellahin who had to seek a new home in consequence of measures enforced by the English consul. But I must tell you the cause of this apparently harsh measure. Last year, the Government demanded payment of 20,000 piasters, arrears of taxes, from one of the Shekhs. This Shekh, whose name, which he has

gained by his many murders, signifies 'Butcher,' sent for
an under-Shekh, and ordered him to raise 10,000 piasters
from his people, promising to get the rest in his own village.
In due time, the money was sent to Butcher, but he, de-
spising Government threats, merely put the money into his
own pocket, till, two months ago, the Pasha sent a peremp-
tory order to appear at Jerusalem with the money. He
then sent again to the under-Shekh, to order him to send
another 10,000 piasters; but he answered that he had
already paid the money. Butcher said that that fact had
nothing whatever to do with the business, as he had spent
it, and would be paid over again, or would attack the vil-
lage of the under-Shekh—at which his antagonist defied him.
Affairs were in this state when Mr Finn heard of it, who
sent at once to the under-Shekh to come to Jerusalem to
explain matters, which he did. During his absence, Butcher
surprised his village; when, after shooting one woman dead,
he had sixteen prisoners brought and laid down before him,
with their arms tied, and these he cruelly slaughtered, one
after the other, with his sword. This cruelty irritated the
other, and getting two other Shekhs to join him, they began
to fight, which continued day after day, till last Friday,
when Mr Finn rode out to the place with two or three
cawasses. Most people would think this pure madness,
when several thousand men were collected together who
would have laughed at five hundred Turkish soldiers. But
no sooner was it known that the English consul had come,
than Butcher and the other Shekhs on his side threw down
their arms, and tying ropes round their necks, came bare-
footed to him. He has taken them prisoners. But as the
Shekh's men would not trust themselves in the consul's

hand, he has had all the houses taken possession of, and the people I saw on the hill were the original owners, searching for some shelter from British vengeance"—which they greatly dread, since Mohammed Ali was driven out by the English; or rather, perhaps, ever since we beat Napoleon, whom they thought invincible, and at whose name they shudder to this day. By the by, they always call him Apollyon.

Jaffa has a decidedly mediæval character, and being built on a steep rock, with many arches and flights of steps, some of the streets are very picturesque, especially when at the angles and openings you get a glimpse of the deep blue sea, often through some archway as old as the Crusades. There is now scarcely any port. A reef of rocks running out forms a little basin for small vessels, but large ships lie out in the open sea. The waves wash the foot of the seaward wall, and landward it is surrounded by a double loopholed wall and ditch, part of which is Roman.

The most remarkable thing in Jaffa is the house of Simon the tanner, which, though modern, there is good reason to believe is really built on the same spot. It is quite at the end of the town, where we know that such trades were obliged to be carried on, and in the court there is a well of water and a trough, such as those used by tanners, now shaded by a fig-tree, from under which you have a beautiful coast view towards the south. There is a stone outer-staircase still leading up from the court to the flat roof-top, as in the days when Peter prayed there.

There is only one gate by which you can go out at Jaffa, which is, of course, always crowded, and the old custom of sitting in the gate is carried out more than in any other

place I saw. The street leads into a small court, partly
roofed over, where the collector of the town-dues sits on a
raised wooden divan, like Matthew of old at the receipt of
custom ; and the seats round the walls of the court-yard are
occupied all day long, but especially in the afternoon, by
the townsmen and others smoking their sheeshehs, and
watching the motley crowd elbowing their way to and fro.
The coffee-houses of the East are the scene of as much dis-
cussion, quite as eager, perhaps as sensible, and certainly
more original than our more civilised palaver : though per-
haps the advantage of originality in the matter of news is
not so clear, as some of the wonderful reports I heard in
Egypt would make one suspect. For instance, one day I
heard that the Russian cavalry had captured the fleet of the
Ingleez ; but the older and more sagacious leaders of
opinion were shrewd enough to say that, Inshallah ! they
had much better have given the Sultan of the Moskows all
he asked at first, for that he never asked for as much as they
will have to grant to their good friends and allies ; and
that now Christians were made equal to Moslems. A rather
bumptious youngster called out, that it was all very well to
call it " assistance." Wullah ! the Sultan El Kebir at Con-
stantinople would soon have made them send plenty of
money and men, but they were so frightened that they took
care to send them at once, without waiting to be forced to
do it ! It is in the Cairo coffee-houses that the Pasha's
police spies glean their chief knowledge of the feelings and
plots of the Eastern mob ; and many a calm and silent
smoker, and loud, careless talker, proves but a serpent in
disguise.

Passing through the market, which outside the gate is

crowded all day long, and past some sheds and awnings where the faithful smoke their bubbling sheeshehs, and sip sherbet in the cool mugreb, we walked out among the gardens which surround Jaffa for three or four miles. From a little hill to the south-east we looked over a mass of orange and lemon trees, apricots and pomegranates, covered with their scarlet blossoms, and the darker green mulberry and fig trees. Gray and white country houses lie half-buried among the trees, and near them the creaking sakias or water-wheels, the cause of all this green beauty, shadowed by great round-headed sycamores, and a few palm-trees raising their gray-plumed heads above the deep mass below. Beyond was the white town of Jaffa, piled on a hill, crowning this glorious garden of richly-varied green, backed by the blue sea, which ended in a broad bay to the north, lying bedded in the arms of the golden sand. The lanes which lead among the gardens are bordered by broad, high cactus hedges, on raised banks, tangled with vines and long grass, bright red poppies, purple thistles, and tall white flowers, like English ones. Indeed, put cactus for black-thorn, and let everything be wilder and more luxuriant, and any straggling English hedge-row, full of wild flowers, will give you an idea of it ; only you must add the scent of the orange blossoms and the huge fig-sycamores spreading their long arms over the road, with the vines fantastically climbing to their foremost branches, hanging down in long wreaths, and swinging in the wind till their ends trail upon the ground.

As we had to hire horses and mules to take us and our baggage on to Jerusalem, we sent for the Shekh of the Mookharees, or muleteers (or the chief man of those who let out horses and mules), and made our agreement after the

usual bargaining. He, of course, began by asking double
what he intended to take, swearing all the time that every-
thing was so dear, and horses so scarce, that he could not
take a farthing less. We, of course, laughed, and said that
it was a very good joke, and that he was a very clever fellow,
but that we were not fools, and had plenty of time to wait
till some other muleteers came in; upon which he protested
by his beard that he had named a very low price, because
we were friends of the consul, and that rather than have
any more words he would take us to Jerusalem, but would
not receive anything; for it was a pleasure to go with
English Howagas. However, we offered about half what
we intended to give, and in half-an-hour we met half-way
at the proper price for the horses, and a present for himself.
After waiting some time, he returned with the owners of
the beasts we were to have, and signed the agreement.
This system prevails more or less through the whole East;
every village, trade, and calling has its Shekh, or head-man,
who is responsible for the conduct of all who are under him,
and no one is allowed to take up any business without his
permission. I had a boy in Egypt who carried my things,
and I found him such a useful servant that when I wished
to take him as cook down the Nile, I was obliged, as he
happened to be one of the snake-charming Dervishes, to say
that I took him to catch snakes and insects; for if I had
called him a servant, the Shekh of the servants would have
made him pay a month or two's wages before his coming
to me. One day at Cairo, I had taken a donkey in a dis-
tant part of the town; the donkey-boy picked my pocket,
and ran away when he saw that I had found it out. When I
arrived at the hotel, the master said, "Never mind, I will

tell the police;" and they sent to the Shekh of the donkey-boys, ordering the man to be sent there, which was done the next day. As I did not wish the man to be bastinadoed, the poor donkey, as I afterwards heard, was the principal sufferer, for he was kept three days at the station-house without anything to eat.

Jerusalem is about forty miles inland from Jaffa; but the road is so rugged that it is a very long day's journey with baggage, so that we left at half-past three, and slept at Ramla, the ancient Arimathea. Passing through two or three miles of gardens, our road lay over open undulating country, which forms the plain of Sharon—half-corn and half-pasture, as far as Ramla. Here and there were scattered the supposed rose of Sharon, which, however, is no rose at all, but a kind of yellow cistus. The road leads by substantial stone-built villages, lying on slight eminences, with gardens of cucumbers, Indian corn, &c., hedged with cactus. One or two scattered groves of very old olives, under which the cattle were feeding, reminded me much of English parks studded with ancient hawthorns, and near them were many fine breadths of wheat, of a thousand acres or more. On the pastures we met very large herds, from one to two thousand milch camels and their young, which still, as in the days of Job, are the great riches of the chiefs.

Having slept at the Latin Convent, we left Ramla the next morning at six o'clock, and found the harvest in full progress. The whole people of the villages were out, the men reaping and handing the corn to the women and girls, who bound it in large sheaves,—not such pretty little sheaves as painters put daintily on the heads of delicate Ruths, but good large donkey-loads, which the sturdy damsels carry on

their heads to large heaps ready for the camels to take to the village. In the rear, the sheep and goats were picking up the leavings, under the escort of the younger children. When I repassed along this road in the autumn, the ground was burnt up to dust, and covered with stately thistles, some seven or eight feet high, dried up and bleached by the burning sun, and yet with every leaf as perfect as if it were green and growing, but by this time looking like plants of the most beautiful frosted silver.

At about nine, we reached the foot of the hills, after passing the ruins of a small village, which was the furthest spot that Richard Cœur de Lion reached, in his march on Jerusalem, and where Saladin forced him to retreat. We here began our tedious ascent through the passes, from which we did not emerge till we came in sight of Jerusalem at five. The path lies along the bottom of the valleys, chiefly in what are the beds of torrents in winter. You climb, and slip, among a mass of loose rocks and stones, between and over rocky limestone hills, covered with bushes of prickly oak, arbutus, and blackthorn, among which the gray rock crops out, generally more or less, in terraces, which are frequently planted with olives. Near Aboo-Goosh, the road is in great perfection, as it dips down into a deep valley in rough, broken steps of bare rock, as steep as the stairs of a house, on which are heaped as many loose, jagged stones as can lie on the ledges; here, riding was impossible. A little further on, were large sloping sheets of white stone, worn as smooth as ice by the constant traffic, where the horses and mules stretched out their fore-legs, and slid down, like Albert Smith down the sides of Mont Blanc. At length, at about five o'clock, after expecting for

the last half-hour that every hill side we climbed would be the last, we came suddenly in full view of Jerusalem.

Few, I think, however careless, have looked for the first time on this scene, without some feelings of solemn awe. We read the accounts of all that passed within and around those walls, with something of the vagueness that always veils the history of times that have gone by 2000 years ago; but, however soon the feeling may wear off or be cast away, it is impossible, with the very spot before you where your Saviour lived and died for you, not to feel vividly impressed with the actual reality of what we have read of, and its intimate connexion with ourselves.

But soon I was struck with the very erroneous idea I had had of Jerusalem. From the west, it does not look at all like a city built on a hill; for, rather below you, at the further end of a barren plain, you see nothing but the embattled walls of a feudal town, with one or two large buildings, and a minaret alone visible above them. To the right, the ground dips into the Valley of Hinnom, but to the left, it is level with the city walls, and its surface is covered with bare ribs of rock, running along it; and it is from this side that the Romans and Crusaders attacked. Behind the city, rather to the north, lay the Mount of Olives, and the long, straight lines of the Moab mountains beyond the Dead Sea, stretching from horizon to horizon, half shadowy and veiled in mist, through which they shone rosy in the evening's sunlight.

The Hebrew name Jerusalem is only used by Jews and Christians; the country people do not know it by that name, but by the Arabic one, El Khuds, or "the Holy." And, indeed, it is the holy city of the world, both to Jew,

Christian, and Moslem! Thither flock the Moslem pilgrims from India and Africa, and Jews and Christians from every quarter of the globe. Mohammed has proclaimed that the last judgment will take place in the Valley of Jehoshaphat, and I saw the pillar jutting out from the temple wall where he is to sit to help the faithful over the bridge like the edge of the razor, which will span the valley. In the same hope the modern Jew comes here to die, and thus avoid the subterranean journey which he believes that all who die afar will have to make from their graves to this spot. But the fierce struggles for the possession of the Holy City have spared few relics of the past. The modern town contains little that dates further back than the days of the Empress Helena; and the entire and sweeping destruction of the city by the Romans has, I believe, obliterated every trace of the previously existing city. We know, after the fire of London, how completely the position of streets and houses was lost, and that the citizens wandered about unable to find the spot where their houses had stood; how much more completely must Jerusalem have been levelled with the ground, when the persevering energy of the Roman army under Titus was long occupied in levelling what the flames had spared! I cannot, then, believe in the authenticity of the reputed sacred spots within the walls. Jerusalem is now a small town, while of old it was a large and populous city; and if the Holy Sepulchre is now far within the city walls, it is difficult to imagine that, when the town was much larger, it could have been outside; and yet the Jews never buried within the walls. When you enter these holy places, and see how gross and degrading superstitions fully justify the Moslem in calling such Chris-

tianity idolatry, one sees good reason why all trace of the
actual scenes of our Saviour's life should have been wiped
away. The Turks, seeing the mummeries of the Greek,
Latin, and Armenian Christians, and their bitter hatred of
each other, fighting and sometimes killing one another in
the Church of the Holy Sepulchre, despise Christians:
though, since our Protestant church stands on Mount Zion,
they have learnt to distinguish between Nozrani Christianity
and Engleez, and say with surprise, " What! no pictures!
no images! the Engleez are not idolaters!" A few years ago,
after some disgraceful scenes in Easter week, the old Pasha
sent to the Greek Patriarch the next year, and said that if
there was any disturbance he would hang five monks, and
all passed off well that year. The following year, another
Pasha invited the three Patriarchs to dine with him, and
after dinner took them into the court before the Holy Se-
pulchre, and read them a lecture on charity.

The population does not probably exceed 10,000—5000
Jews, and the rest half Christians and half Mohammedans.
The Christians chiefly live on Mount Zion and the upper
part of the city. The Jews are forced to live in the lowest
and dirtiest part of the town, where the Turks have placed
the tanneries and slaughter-houses, purposely to annoy them;
and if a Jew were to venture through the court in front
of the Holy Sepulchre, it would be at the hazard of his life,
both from Christian and Turk.

The Jews here are in a very wretched state. Immense
numbers come to die, without any means to support them,
and live on the charity of the European Jews, which is
doled out by the Rabbis, who thus keep them in a state of
dependence and pauperism. They fall into the vices of the

N

East, and the habit of living on alms soon destroys any little
energy which they might once have had. The oldest and
best families are the Sephardim, or Spanish Jews, who
came from Spain at the time of Ferdinand and Isabella.
They are very superstitious. The Askenazim, or German
Jews, mostly come from Poland. They differ completely
from the usual type of the western Jew; instead of the
dark complexion and eye, and aquiline nose, they are gene-
rally straight-nosed and fair : the men have very constantly
transparent pink complexions. Many of them are learned
men, and all strict Talmudists, and are singularly literal in
their interpretation of Scripture. They have in Syria a
synagogue under ground, in order to carry literally out the
text, " Out of the depths have I cried unto thee, O God;"
and the swinging motion of their bodies in prayer is to
carry out the text, "All my bones shall say, Who is like
unto thee ?" (Ps. xxxv. 10.) They are very shrewd and inge-
nious in argument, and, if hard pressed for Bible authority,
they fall back on the fables of the Talmud. Thus, when
they are asked why, if convinced of the superiority of their
faith, they never try to bring over others to the truth? they
reply that they have never received any command to do so,
and besides, that it has been offered to and refused by the
Gentiles; for the Talmud says that when God wrote the two
tables of the law, he first took them to the Moabites, who
said that they would look at them and see; but when they
came to " Thou shalt not steal," they said that they would
have nothing to do with them. Then they were shewn to
the Arabians, the sons of Ishmael; but when they came
to " Thou shalt not kill," that would not do at all for
them; and so on with all nations, till the Jews said that

they would take them and keep them ; so that, having re-
fused them once, the Gentiles had no right to expect a
second offer. The strict Talmud Jews hold that every part
of the law is to be fulfilled, and as Moses left rules to be
observed in divorce, they think that they do not fulfil the
whole law unless they have divorced one wife at least; and
as the girls are married at ten or twelve, or earlier, there are
few who have not done so.

The great body of the Christian inhabitants are divided
between the Greek and Latin Church, whose quarrels and
struggles for supremacy have at last set the world in a
blaze. The present war with Russia arises solely from the
Latin Patriarch having gained a firman from the Sultan,
through the influence of the French ambassador, Count
Lavalette, to allow him to repair a hole a few feet square
in the dome of the Holy Sepulchre; and as this was thought
to involve the possession of the dome, the Greeks complained
to the Emperor of Russia, whose ambassador demanded the
reversal of a favour to the Latins, which was, I believe, an
infraction of privileges previously granted to the Greeks,
and guaranteed by the Russians. But while the world is
at war, the hole is still unstopped ; for, to prevent disputes,
the Turks say they will do it themselves, and they are very
slow in beginning it. At present the Greeks are under a
cloud, and while I was there a Greek monk passionately
complained that the Europeans would interfere, for that
before they had managed to outbribe the Latins—" And
lo !" said he, " now the men at Beit Jala, after costing us
£300,000, have turned back to the Latins!" For a year
before, the men at Beit Jala, a village close to Bethlehem,
who had always been Latin Christians, dissatisfied with the

presents they received, promised, in return for a large bribe, to become Greeks: which they did; but next year the Latin Patriarch paid a better backsheesh, and so they turned back again. The Greeks, as usual, sent great bribes to the Pasha, and to Constantinople, that the villagers should be forced to keep their bargain, but alas! through the interest of the French they lost their cause, and with it their money. —But enough of the squabbles of the present degenerate dwellers there.

When once outside the walls, the passions and handiwork of men no longer intrude themselves, and the everlasting hills still stand around Jerusalem as of yore, stripped, it is true, of their pleasant groves and houses, but substantially the same. About the Mount of Olives there can be no doubt, and the Garden of Gethsemane was probably on or close to the spot now assigned it; for nothing in the East is so unchanging as a road, and it lies just past the bridge over the Kedron below the city gate, where, on the foot of Mount Olivet, the two roads to Bethany diverge—the first spot where one would naturally strike out of the busy track to the privacy of the olive grove; for a garden probably meant, as it does now, an orchard. In vain would you seek, on the hot and rocky hills around, the turf and flowers that *we* look for in gardens. After the month of May every flower would be burnt up; but, coming from the close city, the shade of the olive-trees would be luxury enough. The ancient trees, whose shells, hollow and rent, still send forth vigorous shoots, cannot have been the original trunks which grew in Gethsemane in our Saviour's time; but it is quite possible that they have shot up again from the roots of those cut down at the Roman siege.

A little lower down the valley still stands Absalom's tomb, and another sepulchre of a Jewish king, perhaps Jehoshaphat. The village of Silwan is the Siloam of old; and the king's gardens below are in the only place where the soil and water make it possible to have had large gardens near Jerusalem. These considerations induced me to pitch my tent under an old olive-tree, eighteen feet in girth, standing on the spur of the hill south of Jerusalem, just above the meeting of the valleys of Hinnom and Jehoshaphat, on a small plateau surrounded by tombs, and supposed, with reason, to be Aceldama. From hence, the view embraced more authentic objects of interest than any other around the city. The tombs had been inhabited, and made very comfortable, by early Christian hermits. In one was a supply of water in an inner chamber, so there my kitchen was established; in another, where there are still remains of old Greek fresco paintings, I used to sit and dine, or take a walk during the heat of the day, for it was thirty feet long, and excavated in the solid rock. It was on the 1st of June that I began to paint on this spot, and I remained there till the end of October. A month before I came the hills were green with grass, and gay with flowers; but already these were passed, and the grass was burning up. Patches of ripe corn stood on Zion and Olivet; but in a few days they were gone. I was told that the banks around my tent were gay as a flower-bed in the spring, and my informant had never in his life seen wild flowers in such profusion— hyacinths, convolvuli, and cyclamens of all varieties, and creepers hanging in festoons over the mouths of the caves; but the hot sun soon withers them in their pride. The temperature is not, however, oppressively hot. The summer

sun is fierce between eleven and two; but, by rising early, and dining and lying down in the middle of the day, you escape it; and throughout the morning and afternoon there is a constant refreshing breeze, which makes it less oppressive than the same temperature in England. When I was painting between two and three in the afternoon, I used to hear the stillness broken all at once by the distant rustling of the coming wind, and a few minutes afterwards it came sweeping down the hill-side, swaying the trees and bending down the dry bents on its path. When the first gust was past, it blew on steadily till it died away before midnight, to rise again in the morning.

The mosque of Omar stands on the site of Solomon's temple. At the corner of the wall are some large stones with bevelled edges still standing in their original place, which are supposed to be a relic of the older temple. The hill-side is formed entirely of rubbish, scored and seamed by the winter rains. It has been dug into for some yards, and nothing found but rubbish, broken pottery, and stones, in which some Jewish coins are found. My impression is, that the rock on which the temple stands is precipitous, as Josephus describes it, and that the accumulated rubbish from the remains of the temple have filled up the valley, which was probably deeper than it now is. The bluish colour which pervades this hill and Mount Zion arises entirely from the debris of the ancient buildings. A great traveller told me that there is no such unerring proof of the site of ancient buildings as the blue colour of the earth, which you may observe in every dust-heap in England; and that if, in the middle of a desert, you see a bluish mound, you may be sure that a building once stood there. At the

foot of Mount Zion some of the old terraces remain, and being adapted from the natural strata of the hill, they are probably the same as in Solomon's days; they can be distinctly traced all up the hill. Though looking barren and dry enough through the hot summer, the vine, olive, fig, and pomegranate grow as well as ever to the very hill-tops, and the land wants only good government and an industrious people to flow again with oil and wine. The corn, too, grows well wherever it is planted, and these rocky limestone hills are better soil for fruit-trees than where it is less stony, for the stones prevent their roots from being burnt, and there are numberless caverns and fissures where the water collects. Many of these, enlarged or built up so as to form large water-cisterns, remain, and, wherever they are cleared out and repaired, are as useful as ever; but the blight of Turkish misgovernment and village feuds bars all improvement. The Mount of Olives and the hills around Jerusalem are formed of hard, light-gray limestone, lying in thin horizontal strata, so that the hill-sides form a succession of natural terraces. In the old Jewish time the edges of these were carefully walled up with loose stones, to prevent the soil being washed down by the winter rains; but, during ages of neglect, the greater part of the soil has been carried down into the valleys.

Towards evening, when the shadow of the city throws the Valley of Jehoshaphat into gloom, and rises up the slope of the mount, the Mount of Olives, in the glowing evening light, is of a gloriously beautiful ruddy-purple, which Tennyson has most truthfully described when he speaks of "The purple brows of Olivet." Day after day I have watched the slowly mounting shadows quenching one glow-

ing hill-top after another, until the head of Olivet was the only island of glory above the whole gray landscape, and as the last ray of sunlight flickered on the minaret, the evening gun boomed from the castle of David, and the call to prayer resounded from the mosque of Omar.

One morning, while I was at breakfast, I saw seven or eight bundles of white calico walking on Mount Zion, among the Jewish graves just opposite to me. All at once one began shrieking and crying, and throwing herself about, stamping and wringing her hands, and howling like a school-girl in a wonderful passion. I thought that she had been bitten by a snake at least, but her companions took it very coolly, and she went on through different acts of the pantomime, till she plumped herself down with her face on the

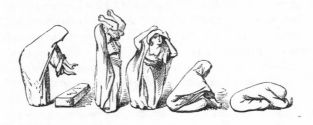

ground with agonising cries and sobs, which I could hear right across the valley. After staying so for twenty minutes, she got up and began laughing and chattering as before. It was a Jewish woman weeping over a grave, and this was considered the proper way of doing it. At the wailing place, by the temple-wall, there was plenty of this theatrical grief, but very little genuine emotion.

My terrace, indeed, overlooking the valley, was in a good place for seeing all that passed. When I began to paint, the villagers were harvesting, carrying down the corn on donkeys, or on their heads, and laying it in great heaps on a smooth rocky platform at the bottom of the valley, which was the threshing-floor belonging to the village. Each man made his own heap, and then men were appointed to watch it by day and night. It is threshed by driving cattle and donkeys over it in a circle, and, as of old, the animals must not be muzzled; but they take care to drive them so fast that they shall not have time to eat any. Their hoofs break the dry straw into chaff, and they winnow it by throwing it up against the wind with wooden shovels, which blows the chaff into a heap, a yard or two off. This serves to feed the cattle through the summer when all the grass is burnt up. This is only one of numberless customs which are the same now as in the days when the Bible was written. You still see the women grinding the corn, two women grinding at one mill; and in 1834, when Bethlehem had revolted, and had been taken by Ibrahim Pasha, the inhabitants all came out in a body to meet Mr Farran the English consul, and strewed their garments in the way, for his horse to tread on, imploring him to intercede for them with the Pasha.

Except during harvesting, the daily life at Silwan is lazy enough. Before daybreak the musical choruses of the donkeys, and the bleating of the sheep, shewed that a move was going to take place, and soon small clouds of black goats and sheep issued from the little rocky village of Silwan, where they had been shut up in caves and enclosures, for fear of the jackals and wolves, and spread over the

mountain side amid the shouts of the Arabs, driving and
leading them to pasture ; and in about half-an-hour troops

of donkeys came galloping madly down the steep road, with
the boys running and urging them on to Joab's Well, and
soon afterwards they were slowly climbing up to the town
with water-skins for the inhabitants. Soon afterwards the
flocks are driven in to water, and they have often to wait
some time till the water flows, for the spring of Silwan is
an intermittent stream, flowing every day at irregular times,
and as the water is the same as that found in the temple,
it has been thought that the troubling of the water, spoken
of at the Pool of Bethesda, may have had reference to this
intermittent flow. The brother of the Shekh, or some great
man, is generally there to secure equal justice, and calm the

excitement; for the screams of the women and shouts of the men, all quarrelling, and trying to secure as much as he or she can for their own garden, quite drown the plashing of the little cascades of water leaping from terrace to terrace, and running along the channels to distribute itself over all. When the head-man thinks that one part has had a fair share, he has that channel stopped; and then every man, woman, and child belonging to those gardens, bursts into a scream of indignant remonstrance at the injustice of giving them so little; for, as usual, no one thinks that he himself has been rightly dealt with. After the sun goes down, the long lines of goats and sheep wind back to the village, along the mountain sides, with the shepherd in front, and generally a boy behind. The goats always go in front, and are much more independent than the sheep, who never straggle, but always keep in the shepherd's track, and come at his call. The Syrian sheep are very odd, with large round cushions of fat hanging down instead of tails, and a little curly tail coming out of the middle of it.

After supper, the men all assemble together in a square place in front of the Shekh's house, and discuss the affairs of the village. The old Shekh has a place reserved for him in the corner; and if he is not present the next in rank takes his place, with the old men around him. The boys make coffee if any guest comes, and carry coals to light the pipes; and smoking and talking go on till they break up for the night. There is none of that deferential respect for rank which you see in England, or, at least, it is shewn in a different way; for the poorest speaks as loudly and authoritatively as the greatest. There is more respect from the younger towards the older, than from the inferior to his

superior. At these meetings, complaints are discussed and judged, and quarrels among each other arranged after hearing both sides.

But to return to the description of the country :—One thing struck me much, and that was, in what a small tract of country the great events of the Bible took place. Most of the remarkable places are within a few miles, and the greater number within sight of any of the hills around Jerusalem. From the top of the Mount of Olives, you see the Dead Sea, the plains of Jericho, the hills of Bashan and Gilead. From the top of Nebbi Samuel, on the other side, you look over the whole hill-country of Judea and the plain of Sharon, the country of the Philistines to the sea ; and from the Hill of Evil Counsel, you see Bethlehem and the country south towards Hebron. The view from the top of the Mount of Olives is certainly one of the most striking in the world. On the one hand, the town of Jerusalem lies spread as a map before you; and on the other hand, the Dead Sea sleeping in unruffled calm over the ashes of Sodom and Gomorrah. Though fifteen miles away, its waters seem to lie close at your feet—4000 feet below you, calm, blue, and motionless ; for it is so hemmed in by mountains that the wind scarcely ever reaches the bottom of its low grave to ruffle its mirror surface, which so faithfully repeats the mountain sides that rise from its waters, that you can scarcely tell where rock and water meet. The Jordan winds circuitously through its desolate plains, and the mountains of Moab and Bashan seem bare rocks and mounds of naked earth, though a good telescope shews you trees and villages in Bashan and Gilead. Between you and the sea is a wilderness of mountain tops, in some places tossed up like

waves of mud, in others wrinkled over with ravines, like
models I have seen of mountains made of crumpled brown
paper ; the few nearer hills are whitish, strewed with rocks
and bushes. The Moab mountains are twenty or thirty
miles beyond the sea, and their tops present one calm un-
broken line, stretching from north to south as far as the eye
can reach, half-veiled by vapour, through which you see the
dimmed shadows and sunlit rocks, as if they were a phan-
tasm in the clouds, and not this solid earth.

Passing over the hill-top, and round a second summit
about a furlong off, and joined by a neck to the Mount of
Olives, through groves of olives, apricots, and figs, which
covered the slope, we came just over Bethany, which stands
on a little platform at the head of a valley opening towards
the east, and lying in an amphitheatre of trees and
orchards, which stretch down to the foot of the hills in
which she lies ; while in front all is barren and desolate ;
for you look straight on the north of the Dead Sea and the
plain of Jericho, where the Jordan winds through a plain
as white as salt, surrounded by those brown wavy hills. In
front are two or three huge rounded backs of hills of
white rock, or chalk, thinly sprinkled with yellow herbage ;
the one on the right crowned by the square houses of Abou
Dis, which is generally thought to be Bethphage. There
is much that is extremely grand and beautiful, and yet
much that people would call untrue when painted. The
wonderful haze over the sea made the sky green, and
almost orange, near the horizon. The Moab mountains
were pale, rosy gray, with the Dead Sea lying at their feet
of a deep and solemn blue, the dark thread of the Jordan
winding through the white plain on the left :—before it the

bare brown mountains, the nearer hills looking all white and gold in the sun, which now getting low, threw three or four bold, dark purple shadows from their brows; midway between you and the sea, two patches of green on the brown hill-tops shone like emeralds in their setting of desolation, and the foreground to this scene was the bright green orchards glittering in the sun. Bethany itself is a very picturesque village, crowned by the remains of an old ruined church, below which lies the village on a series of terraces. The people were more civil than the rough Silwanees, and there were two or three good-looking girls, who neither ran away nor called us "pigs," which was a pleasant change. The Syrian villagers are independent, and generally civil enough, unless they think they can frighten you into giving them larger backsheesh; but the Arabs of the east, towards the Jordan, are much more savage, and will let no one through their country without buying their protection. This evil is much increased of late years, since English travellers have spoiled the market by paying anything that was asked. They every now and then make a raid on their more peaceful brethren. While I was there, the Arabs from the Jordan came down to attack the town of Nablouse, with 300 men mounted on their best mares, with lances and spears; but the inhabitants stood firm, and a few bullets sent them back. They said afterwards they were not a bit afraid, but their horses would not face the "cherry stones." But the favourite amusement is fighting, after all; and every village has a feud with its neighbour. The present Pasha has stopped the fighting, and the Shekhs complain bitterly that they had given the last Pasha large bribes to let them fight,

and now this man won't let them. One night a woman
was shot under an olive-tree, just below my tent, by a man
from the next village, who crept up at night and saw a
man and the woman by a fire; he shot at the man, and
the bullet went through his lip and killed the woman, who
was behind him; but this was an accident, for they never
hurt women on purpose. There was a great hubbub in the
village, and a dozen young fellows seized their guns and
started after the man, but he got off; and when the harvest
is well over, they will go to the other village for revenge,
unless the blood-money is paid. They say the man who
did it is brother to one whom the Silwanees killed a year
before. Mr Finn, the consul, was encamped with his
family in the country; and one morning he heard a great
noise and bullets whistling round the tents, so he went out
and found that two neighbouring villages were fighting: so
he begged them to go and finish it a little further off, which
they did with a great many polite excuses.

The coarse striped abbayah worn by the men throughout
Egypt, Arabia, Koordistan, Mesopotamia, and Syria, is the
coat of camel's hair, and a leathern girdle round the loins.

The women wear a blue gown, striped with red and
other colours, and ornamented on the breast and sleeves
with any patches of bright colours they can get. I have
no doubt that Joseph's coat of many colours was a dress
ornamented like this; for their favourite children's dresses
are always so adorned. The gown is bound around the
waist by a girdle, which is tied in a great knot in front,
with the long ends hanging down. On their heads, over a
cap ornamented with silver or gold coins, they wear an-
other which is padded, to carry burdens on, and over this

is thrown a long veil of stout coarse linen, fringed at each end : it is two yards long, and is doubled so as to hang down the back, so that in such a veil Ruth could carry a good supply of corn.

[The lecture concluded with a description of a marriage at Silwan, which has been given previously in one of his letters.]

THE END.